To my family, who endured.

Contents

Introduction

 The sandy beach of an ocean, the weedy shallows of a lake, the muddy edge of a flooded field . . . in these or any number of other wet areas, shorebirds may be seen feeding or resting. The long-legged shorebirds quietly go about their business in the shallows, probing the soft bottom for food, while sandpipers and small plovers on the beach are in constant motion: racing along the water's edge, suddenly darting in, then quickly springing back onto the beach again ahead of the waves.

Sometimes shorebirds seem indifferent to human presence, allowing you to approach them within a few feet for a close look. At other times, the mere hint of a human will send them into hurried flight, allowing only a frustrating glimpse. And fly they can. With wings shaped for efficient flight not only can they travel quickly, but some species are also long-distance champions, flying thousands of miles from nesting grounds to wintering areas.

Most shorebirds display distinct markings and patterns but subtle colors. They also exhibit a wide variation between breeding and nonbreeding plumage. These differences, along with a multitude of varied physical characteristics, pose a challenge to the shorebird painter to accurately portray the proper plumage, color, shape, and attitude. This book will help you to meet that challenge, introducing you to materials and techniques, the distinctive physical characteristics of shorebirds, and step-by-step painting examples that will help you to paint shorebirds successfully.

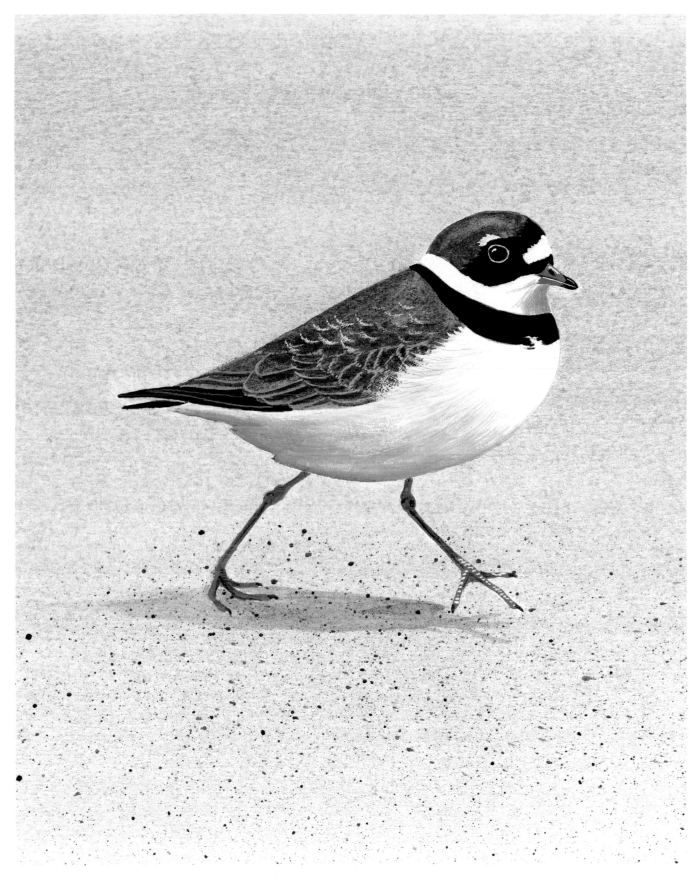

1
Painting
Mediums

 Many mediums may be used in bird painting; however, two in particular—gouache (opaque watercolor, designers colors) and acrylic—are used more frequently and with greater success by most wildlife artists. These two media, while dissimilar in some respects, are alike in others. They are both water-soluble, have good covering ability, dry rapidly, and may be used opaquely or transparently.

Oil paints and transparent watercolors are beautiful media but do not lend themselves easily to bird painting. Oils require oil solvents as a thinner, are rather thick to work with, and dry quite slowly. They may be used thinly, but this technique requires a great deal of experience. The newer water-based "oil" paints are thinned by water but work in a manner similar to traditional oils. Conversely, transparent watercolors are applied very thinly and dry quickly. Their great disadvantage is their inherent transparency, which means that it is hard to cover one color with another, and mistakes are difficult to correct.

A word of caution here: whichever media you choose to work in, know that many of the pigments used are toxic or carcinogenic in one degree or another. This does not mean that under normal conditions painting is hazardous to your health; it merely means that you should use common sense. After painting, wash your hands before eating or smoking, or if there is excess paint on your hands because some toxic materials may be absorbed through the skin. And *never* point your brush by putting it in your mouth.

You can purchase a wide variety of premixed colors, but it is wise to get only a few basic ones (red, yellow, blue, green, black, white, raw umber, burnt sienna), work with them, and then buy additional colors as needed. Whether you are a beginner or an expert, painting is easier with a limited palette.

Color mixing in any medium is almost an art in itself. It would be best to familiarize yourself with the basics of colors and color mixing by getting a beginner's book on color theory and then experimenting, blending colors to obtain the best results. When you obtain a desired color, either while experimenting or while involved in a painting, make a note of which colors were mixed to obtain that color. Never trust your memory; later you may attempt to duplicate a particular color and not be able to do so. Making color notes is tedious but worthwhile.

Gouache

Gouache is the easiest medium to work with because of its forgiving qualities; its opaqueness allows mistakes and corrections to be made and the paint remains workable even when dry, permitting blending and scrubbing out of colors.

Gouache may be used thinly to give a very transparent color, layers of color may be allowed to build up, or it may be used in a completely opaque manner with darks over lights, or vice versa. Whichever effect you choose, it is accomplished with the addition of water to the concentrated pigment. However, gouache should not be used too thickly or it will crack.

The dry gouache paint has a matte, nonglossy finish and great visual weight. It is available in a wide variety of colors, but, as with most pigments, the degree of *light-fastness* (permanence) can vary widely.

Most color charts have a key that indicates the light-fastness of the

various colors. The ratings are: (E) Excellent; (V) Very Good; (G) Good; and (F) Fugitive. For art that is to last, it would seem folly to use any colors below the Very Good rating. Not only does the permanence of color vary, but same-named colors from different manufacturers can have very different color values, especially in the earth tones. The best approach is to familiarize yourself with the color differences between the brands via color charts, which are available free or at a nominal cost from the manufacturers or art-supply stores, then choose the colors and brands you are most comfortable with.

When you look at the color charts you will notice the great variety of shades of the basic colors (reds, yellows, blues, etc.), but don't ignore the blacks, which have color characteristics all their own. *Ivory* (bone) *black* has a brownish tone, *lamp black* has a bluish tone, and *mars* (jet) *black* is a deep velvet black. When mixed with other colors or white they give very different results.

Gouache may be purchased in tubes, cakes, or jars, with tube gouache being the most readily available. The paints in tubes and jars remain workable over a long period of time as long as the caps are kept securely in place. The key is to keep air away from the paint, especially in tubes where the paint is more viscous to begin with. After squeezing needed paint from a tube, whether transparent watercolor, oil, acrylic, or gouache, never squeeze the sides of the tube to suck the paint back in—this only allows excess air into the tube and accelerates drying in the tube. With gouache and acrylics it is advisable to put only the colors you are going to use on the palette as you need them because they will dry out on the palette. The gouache may be worked when dry, but acrylic will dry completely, rendering it useless.

A shortcoming of gouache is that because it remains water-soluble even when dry, it is possible for a color already painted on a picture to bleed through into another color applied over it if the second color is worked too much with the brush. Even when dry, the surface of gouache will rub off slightly with vigorous movement, so it is advisable to place a small piece of paper under that part of your hand that is touching the art so that traces of color already applied are not picked up and dragged around.

Despite the minor disadvantages of gouache, it is still the most versatile and easiest medium to use in bird painting on flat surfaces and is the first choice of beginners and experts alike.

Gouache Media

Gum arabic is the basic binder used in the manufacture of gouache. It is also used, in small quantities, to increase the transparency of gouache and impart a slight gloss to the normally matte finish. It is most commonly available in small jars.

Ox gall is made from the bladders of oxen. This natural wetting agent is the best material to increase the uniform flow of gouache, particularly in washes. Only small amounts are used, and it is available in small jars.

Acrylics

As mentioned previously, gouache and acrylic have much in common: rapid drying time, water solubility, opaque or transparent use. But there the major similarities end. While acrylics and gouache are suitable for painting

on flat surfaces, acrylics are best for painting birds in the round, whether wood or clay. The basic color selection of acrylic is not as broad as gouache, and is available only in tubes and jars. Again, color charts should be consulted for the variety of colors available. The consistency of the paint in tubes and jars is quite different: the paint in jars is less viscous and easier to thin to a flowing or brushing consistency.

One of the difficulties a beginner encounters is in achieving the proper working consistency for acrylics. Whereas gouache cannot be used thickly, acrylic may be used from a transparent wash to a thick impasto; obviously, the working consistencies can vary widely. A rather disconcerting quality of acrylics, especially for beginners, is that even though they may appear to be opaque and dense on the palette, they work very thinly on the painting surface and it may take two or three applications to achieve a solid color, if indeed that is your intent. There is no formula; only experimentation and experience will teach you the right "feel" for the particular painting being done.

The short drying time of acrylic paints cannot be emphasized too much simply because when acrylics dry, they are *dry*: they become extremely hard and are not water-soluble. This means that wet-in-wet blending between colors must be done while the paints are still workable; however, a blended or shaded effect may be achieved if a graded wash is put on over an already dry color (see Techniques). The hard nonsoluble surface is a distinct advantage when applying glazes (thin washes of other colors) or other solid colors over an already painted surface because the paints will not bleed into one another. The surface of dry acrylics will not rub off, thus your painting hand won't drag colors around.

Acrylics have excellent permanence and may be used on virtually any surface. A ground coat of gesso is necessary on many surfaces, especially canvas, wood, and clay. The colors have great visual weight and look juicier and brighter than gouache; the surface of the dry paint has a slight sheen.

The big precautionary note for acrylics is that, because of their rapid and hard drying qualities, care must be taken to clean brushes and other tools immediately after use because dry acrylic is virtually impossible to remove from many surfaces, including clothing and floors.

Initially, acrylics seem difficult to control, but don't be dismayed by first attempts—work with them until you've mastered their use. They are a valuable and versatile medium, whatever the painting surface.

Acrylic Media

Acrylic retarder is a gel that retards the drying time of acrylic paint. It is usually available in tubes. Care must be taken to add the proper amount of retardant to the paint; the instructions on the container should be followed.

Acrylic flow release is added to acrylics in small amounts to reduce surface tension, thus increasing the flowability and permitting more even washes on paper or paperboard.

Acrylic gel medium is a thickening material that not only allows an impasto effect to be achieved, but makes the paint more transparent. It has very limited uses in bird painting.

2
Brushes

 Almost any hair, bristle, or fiber may be used in the manufacture of brushes for painting, and all have different characteristics.

The brush is the most important tool in bird painting. There is nothing more frustrating or self-defeating than trying to work with a poor brush. Purchase the highest quality brush(es) you can afford. Don't be dismayed at the array of shapes and sizes; only a few good brushes are necessary for successful bird painting.

What determines a good brush is a combination of abilities: to carry an adequate load of paint, to hold a sharp edge in a flat brush, to hold a sharp point in a round brush, and to spring back into shape after use. Emphasis here will be on the materials and shapes used most frequently in bird painting with gouache and acrylic paints.

Types of Hair and Filament

Kolinsky Sable. The finest and most expensive brushes made are from Kolinsky sable, but even these will vary in quality depending on the manufacturer. Kolinskys are typically found in the round shape and usually display all of the desirable qualities of a good brush. Although there are many brands, the two I recommend for availability and consistent quality are the Strathmore series 585 and the Winsor & Newton series 7.

Red Sable. Sable hairs that are of a lesser quality than Kolinsky, usually they are not as springy, and in rounds do not point up as well as Kolinskys. In other shapes—flats and filberts—they are fine brushes.

Sableline. A fancy name for dyed ox hair. They do not point up well in the rounds but have the ability to hold a good load of paint and are fine flat and large wash brushes.

Nylon. Sometimes designated as synthetic sable, nylons have great spring but little ability to point or hold paint. The development of synthetic filaments has not yet achieved the quality found in natural hair brushes.

Blends. The most common blend is nylon-sable, and although a better brush than pure nylon, it is still lacking in paint retention and the ability to hold a fine point.

Shapes of Brushes

Standard Round. Usually just called a "round," this is the most popular and versatile shape, found in a variety of sizes. Though this is called a *standard* round, various characteristics such as hair length may vary between manufacturers. The two most popular brands are Winsor & Newton and Strathmore. The brush I recommend in this style is the Strathmore Kolinsky Sable #585, an all-around good brush that holds a very fine point.

Designer Round. These have a longer, thinner shape than a standard round and come to a narrow sharp point that can pull a very fine line. This is a good style but not quite as versatile as the standard round.

Flat. There are two categories to be considered in this style: watercolor and oil flats.

Watercolor flats. Initially, this brush category may seem confusing because watercolor flats may also be called *aquarelles*, which are large, thick flats or one-stroke brushes that usually have slightly longer hairs than nor-

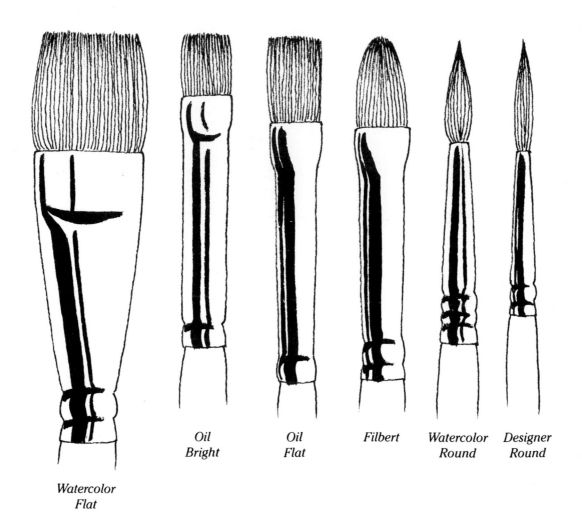

*Oil
Bright*

*Oil
Flat*

Filbert

*Watercolor
Round*

*Designer
Round*

*Watercolor
Flat*

Brush Shapes

mal flats. Regardless, they are all watercolor flats and all are used primarily for washes or filling in large areas. They are generally not found in very small sizes, and the most common sizes are $1/4$, $3/8$, $1/2$, $3/4$, and 1 inch. Red sable and sableline are the preferred hairs in this shape; lesser-quality brushes in this shape have a ragged edge, don't hold much paint, and have the annoying habit of losing hairs in painting. Another brush to be considered here is a large flat called a *wash brush*, used, as the name implies, for putting washes on large flat surfaces. A good large wash brush is the $1^{1}/_{2}$- or 2-inch Oxhair by Strathmore.

 Oil flats. These come in a much greater variety of sizes, have shorter hairs, and are more stout than watercolor flats. Oil flats are used for oils and acrylics on canvas or wood. The *bright* is another flat but with slightly shorter hairs than the oil flat.

14

12

10

8

7

6

5

4

3

2

1

0

00

000

Watercolor Rounds (Actual Size)

Although many surfaces may be painted on, only those widely used with gouache and acrylic will be covered here. **Watercolor Papers** are available in a wide variety of weights, finishes, and shades of white and gray. The following is a general overview of the terms used to describe watercolor paper and its characteristics.

Watercolor paper is commonly available in three finishes, or surface textures, although the degrees of texture on same-named finishes can differ widely from one manufacturer to another. These papers are available in rolls, pads, and individual sheets. Although watercolor paper is intended for use with transparent watercolors, gouache may be used on it with great success; however, it is not recommended for the inexperienced acrylic painter.

Hot Press is the smoothest surface and will take very fine line detail and is used mainly for hard-edged paintings. The surface has very little "tooth" (roughness to the fiber) to hold paint, which has a tendency to lift off the paper at inopportune times.

Cold Press is the intermediate finish between hot press and rough. With a moderate surface and tooth, it is the finish of choice for the beginning artist.

Rough is, as the name implies, a very rough finish, and because of this is a very difficult surface to work on. It is an attractive surface but does not lend itself well to detailed paintings.

Watercolor paper is listed by weight as well as finish, and if the paper

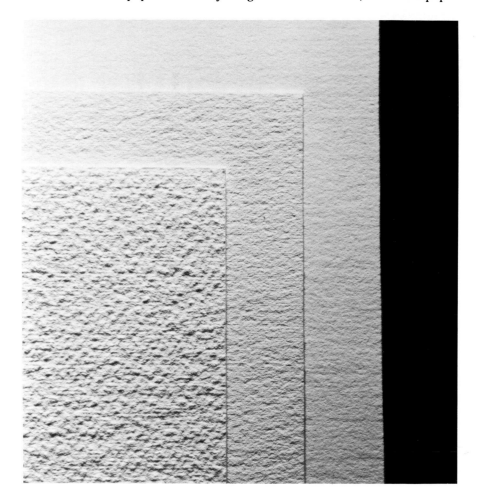

Watercolor paper surfaces. From the left: *Rough; Cold Press; Hot Press*

dimensions are the same, the higher weight will be thicker paper. Size is important because the standard is based on how much a ream (500 sheets) weighs, no matter the size. Thus, a larger sheet of the same thickness will be listed at a greater weight.

Most lighter-weight watercolor papers must be stretched prior to use to avoid buckling. This is a simple process. Soak the paper in a pan or tub of water, remove the paper when thoroughly wet, and drain off excess surface water. Then place the wet paper on a flat surface, such as a drawing board, and tape the edges all around using a gummed paper tape. Tack the corners through the tape and let dry. The paper will dry very tight and may be used taped to the board or cut free. Stretching is not necessary with heavy-weight watercolor papers.

Illustration and Watercolor Boards are stiff boards with either illustration paper or watercolor paper adhered to one side. Because of their stiffness, these boards can stand rougher treatment than papers and do not require any prepainting preparation.

Illustration board is lighter in weight than watercolor board and has a slight tendency to warp when large areas are painted. To remedy this problem, merely brush a thin coat of gesso or paint on the reverse side to equalize the pull of the paint, thus flattening the board. Illustration boards are available in two surfaces, *hot press* and *cold press*, and the hot press is the smoother and less desirable of the two. Cold press provides good surface for both gouache and acrylic.

The difference in thickness between Illustration Board (left) *and Watercolor Board* (right).

Watercolor boards are made with a heavier backing than is illustration board and thus are more resistant to warping. Since the surface is watercolor paper, it responds well to paint. The three surface finishes are the same as those already described for watercolor paper. The preferred watercolor board is Crescent #114 cold press, a very heavy board with Strathmore watercolor paper adhered to it. Gouache and acrylics may be used with great success on this fine board.

Matboards are constructed of tinted paper adhered to stiff backing. There is a temptation to use this board for painting, and it can be done; just be aware that the tinted paper fades to a great degree.

Hardboard, commonly known under the trade name Masonite, is made of compressed wood fibers and is found in tempered and untempered forms. Only the untempered board should be used for painting because the tempered board is impregnated with oil. Prior to painting, the board must be coated with acrylic gesso to provide a suitable ground (surface) for the paint. Preparation with gesso requires rolling or brushing a base coat of thinned gesso, then sanding with a fine sandpaper and dusting and applying more gesso, repeating the process till at least three coats of gesso are on the surface. The reverse side of the board must also be coated but need not be sanded. Gouache may be used on hardboard panels but only with limited success. Acrylics work well on hardboard but it does take some patience, because initially paints go on the slick gesso surface rather irregularly. However, after additional applications of color the painting goes smoothly. A finished acrylic painting on hardboard is very crisp and bright.

Primed linen canvas

Canvas. Both linen and cotton are referred to as canvas and both are available in different grades and weaves, the tighter weaves being the more expensive. Gouache may be used on canvas, but acrylics have much greater success. Because of the inherent texture of the fabric, canvas does not lend itself easily to fine-line paintings—except for the portrait linen canvases.

Cotton canvas is available in several forms: rolls, panels, pads, and prestretched, and the form most suitable for painting with acrylics is the prestretched acrylic-primed canvas. Found in a wide assortment of sizes, these canvases are ready to use and easy to store. The surface of cotton canvas can be rather coarse, with irregularities in the weave.

Linen canvas is more tightly woven, stronger, smoother, and more expensive than cotton canvas, and is available only in rolls or prestretched and primed. The latter is preferred for our purposes. Because of the weave and stability, linen canvas is the preferred choice of most artists because its fine surface permits detailed paintings.

Wood Panels have historically been used for painting surfaces; however, the concern here is not for wood panels but for carved wood used by modern bird carvers. Finished carvings must be primed to accept paint and to provide a white ground that enables colors to be crisp and clear. Wood must first be sealed with clear lacquer or sanding sealer, then one or two coats of acrylic gesso, thinned to the point where it will not fill in carved detail, is brushed onto the surface. When dry, this provides an excellent ground for acrylics. Gouache is not suitable for carvings because of its soft surface.

Primed cotton canvas

Additional Media, Tools, and Accessories

Just a peek inside an art-supply store or catalog is enough to bewilder any artist. Besides the array of brushes, paints, and paper, there are myriad accessories and gadgets, some useful—some not. Listed here are only those additional art items necessary for successful bird painting.

Liquid Masking Fluid (Liquid Frisket) is a thin rubber-cementlike fluid that is painted over an area to be left white after painting washes or specific areas. Use a worn out or inexpensive brush to apply the frisket because it dries and balls up in the brush quickly. Immediately after use, wash the brush in water. When the background color is completely dry, the frisket is removed by gently rubbing off with the finger(s) or with the help of a rubber-cement pickup. Liquid frisket is used extensively in bird painting.

Palettes may be made of metal, plastic, paper, china, wood, or glass, in any shape or size, with wells to hold the color or flat, and some have lids to keep the paint moist. Despite the variety available, the best palette is usually the simplest, and anything that will hold paint may be used. Most acrylic painters prefer something that is peelable or disposable like an old plate, pizza pan, or hardboard scrap, and a pan with a shallow lip or enameled tray is ideal for gouache.

Transfer Paper is a thin paper coated on one side with graphite, and it is used to transfer a drawing to a second surface. It is available commercially or may be easily made by first rubbing a thin coat of graphite from a soft pencil or graphite stick on one side of a piece of tracing paper or on the reverse side of a drawing, then smearing the graphite around with a tissue to get a more even coating. To transfer a finished drawing to the painting surface: prepare the back of the drawing as described or place a piece of transfer paper between the drawing and second surface, trace over the lines of the drawing, remove the drawing, and the traced lines are transferred to the painting surface. This acts in the same way as carbon paper does, which, incidentally, should not be used for drawing transfers because carbon paper smears badly and is difficult to erase. If the transfer is to be made onto a dark surface that will not show graphite, smear the back of the drawing with silver- or white-colored pencil instead, and white lines will be transferred.

Brush Washers or *Holders*, as mentioned previously, are handy and inexpensive pieces of equipment.

Water Jars hold the water used for diluting paints and washing brushes while painting. From hand-thrown pots to canning jars, anything that will hold water will do.

Spray Bottles are used for the even prewetting of surfaces. Trigger types are superior to pump types; they may be purchased empty at hardware stores and beauty shops.

Sponges, both natural and artificial, have a variety of surface textures and are used for special effects as well as for controlling water and washes.

Hobby Knives (X-acto types) are used in painting for scratching white lines on painted surfaces and for carefully removing unwanted hairs, paint flakes, or whatever may suddenly appear on a painting.

Tissues, *Paper Towels*, and *Rags* are always handy for removing excess paint or water and for blotting paint from brushes.

Q-Tips provide a ready-made instrument for blotting small areas of paint, as in lifting off (see Techniques).

4
Techniques

 All the basic techniques shown here apply to gouache; however, not all apply to acrylics, because when dry, they cannot be reworked. Though every effort is made to indicate how the techniques are executed, it is difficult, if not impossible, to describe the precise consistency of a paint, wetness of a wash, or amount of pressure on a brush. These are variables that can only be learned through experience. Even veteran artists keep a scrap of board handy while painting to check for consistency, color, load of paint in the brush, or to practice line shapes. Don't be discouraged—these techniques are easy to master through practice. It is important, once you have mastered the techniques, not to overuse them. Learn when to stop.

Flat Opaque Colors—Dilute the paint to a creamy consistency and, using the appropriate-size brush for the area being filled, use broad strokes to fill in with opaque color. Acrylics may require two coats to cover completely.

Wet-in-Wet Wash—This technique is used for backgrounds or on the bird painting itself, wherever a continuous, even, transparent color is desired. For a large background wash have a puddle of thinned paint ready to go, then place the board on a slight angle so that the water and then the paint will flow slowly and evenly down the board. Wet the board surface thoroughly so that it shines, then, starting at the top of the board and working downward, brush on the thinned paint from side to side, adding paint and brushing until an even wash is obtained. If the first wash is too thin, wait until it is completely dry and then repeat the process. When working a small area on a bird, wet only the area to be colored and brush carefully. The paint will brush evenly into the premoistened area, giving a beautiful, thin, even coat.

Graded Wet Wash—The preparation is the same as for a wet-in-wet wash; the difference is that the brush is charged with paint only once, and as the brush works down the board there is less and less pigment, thus the

flat opaque colors

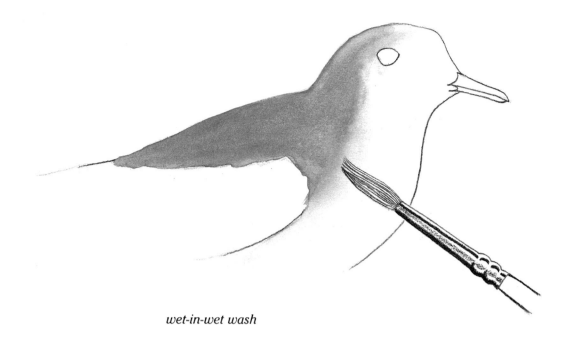

wet-in-wet wash

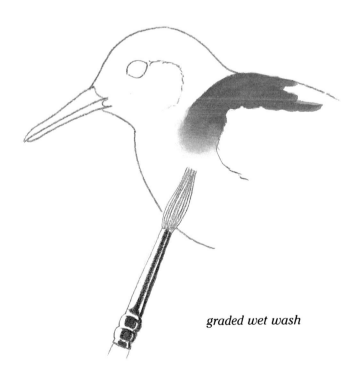

graded wet wash

effect is a graded tone. This is a very useful technique in bird painting, especially for achieving a shaded effect in acrylics by grading a wash over a base color (glazing).

Wet Blending—Paint two areas of color close to each other on a damp surface and work the edges of each color into the other while still wet until a blended effect is achieved. This technique may be used with acrylics but you must plan ahead and work quickly, while the paint is still wet.

Dry Blending—Easily done with gouache but not possible with acrylics, this is, quite simply, blending two adjacent dry colors with a clean, damp brush. Use a light touch on the brush and move it back and forth across the edges of the colors until they are coarsely blended, then brush along the edge to achieve a smooth blend. This is very handy for softening the edges of thin lines, as on wing edges.

Glazing—This is an application of a thin wash of color over an already dry one, allowing the colors to mix. A graded wash painted over a base color is an example of glazing. Acrylics lend themselves beautifully to this technique, but care must be taken with gouache not to overwork the second color on the surface or the colors will bleed together.

Drybrush—Though this technique is rarely used on the bird image itself, it is employed frequently on the supports (twigs, logs, and so on). The

wet blending

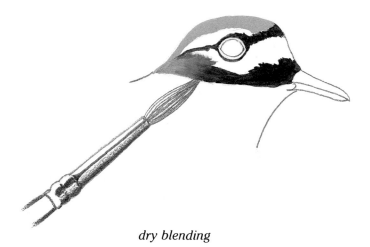

dry blending

glazing

brush is charged with color, blotted until almost dry, then dragged across the surface, creating an unpredictable broken, shaded effect. The tip or side of the brush may be used.

Splitbrush—Also known as *heeling* or *feathering*, this is a versatile and fun technique, and one that invites overuse. A round brush is charged with paint and severely pinched or pressed down at the heel (where the hairs and ferrule meet) until the hairs spread apart. Then the tips of the spread hairs are brushed lightly across the surface, making a series of tiny lines. The brush may be blotted to produce drybrush broken lines. A graded or blended effect may be achieved by using a series of light short strokes on the edge of a color. Short light splitbrush strokes are a very effective way to soften the edge of wet acrylic paint, producing a blended effect. Be warned that this is very hard on brushes; old, worn brushes are recommended.

Tipping—The filbert-shaped brush is most effective for tipping, and care should be taken not to overuse this technique. The brush is not held in the conventional manner, like a pencil, but rather, is held almost parallel to the painting surface, but at a slight angle. The brush is charged with paint and the tip is lightly pressed to and then lifted from the surface. Varying amounts of paint, degree of pressure, or a pressing-then-pulling motion, all produce a wide variety of featherlike marks.

Lifting Off—Rather than adding color to the surface, this is a subtractive technique for removing color (it cannot be done with dry acrylics). A brush filled with clean water is lightly scrubbed over a selected area of dry paint. While the area is still wet, a Q-tip or clean, dry brush is used to lift the loosened pigment from the scrubbed area. This leaves a subtle highlighted area, the shape and size of which is determined by the motion of the wetted brush.

Detailing—Usually the last technique used on a painting, this is the addition of finishing detail, usually employing a small fine-point round brush.

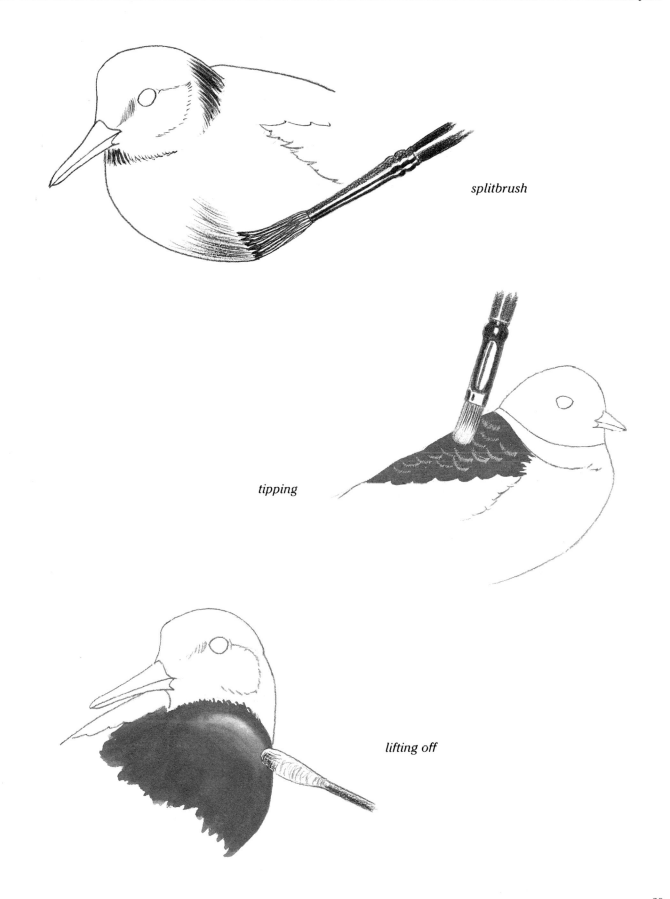

splitbrush

tipping

lifting off

In bird painting, the wing edges, highlights, and other finishing touches are described as detailing.

Spatter—This technique is not used on the bird but rather on the background to suggest an irregular sandy-like surface. It is accomplished by dipping an old toothbrush in very thin color, then lightly rubbing the bristles of the toothbrush with a stick or finger. As the bristles snap back and forth, random-sized dots of color appear on the painting. Both light and dark colors may be spattered. To control the area being spattered, frame it with a piece of torn paper; this will give a varied, more interesting edge to the spattered area.

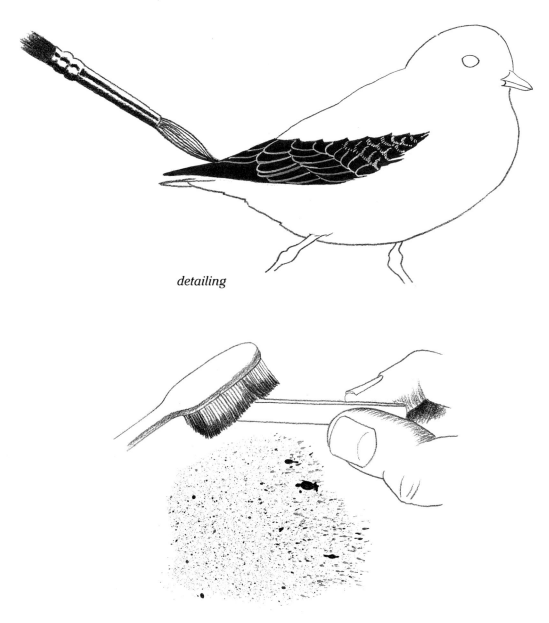

detailing

spatter

5
Putting the Techniques Together

Although not all the techniques previously described may be used in any one bird painting, many can be. In the following example, transferring and liquid masking are employed.

Because the semipalmated plover's (*Charadrius semipalmatus*) breast is white, the same color as the painting surface, it was necessary to put on a thin color wash to separate the bird from the background. The painting was done with gouache on cold press watercolor board with a #2 Kolinsky sable round, except for the background wash, which was painted with a 1¹/₂-inch flat wash brush.

A finished semipalmated plover drawing on tracing paper is prepared for transfer by rubbing the reverse side with graphite.

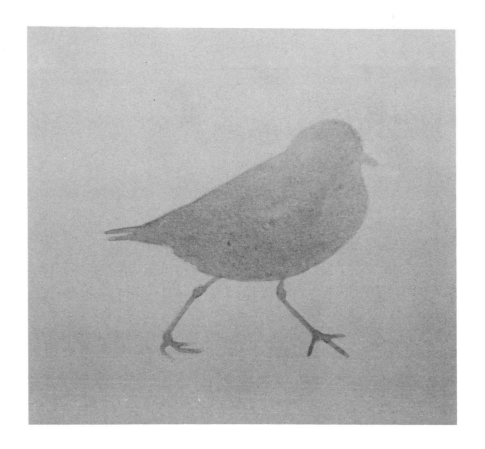

At this time, only the outline of the bird is transferred to the board and the area to be left white is coated with masking fluid.

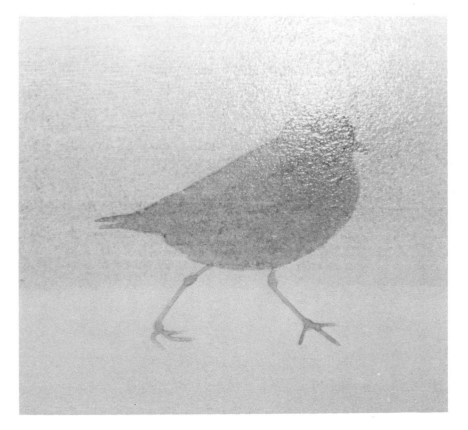

The board is moistened thoroughly using a spray mister and the clean wash brush to spread the water evenly. Then, a thin wet-in-wet wash is applied with the wash brush loaded with thinned paint.

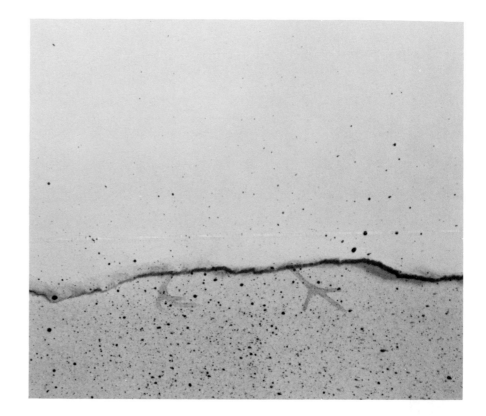

After the wash is dry, a piece of torn paper is placed over the top part of the picture and a dark color is lightly spattered with a toothbrush to indicate sand.

After the spatter is dry, the masking is rubbed off, revealing the white area of the bird to be painted.

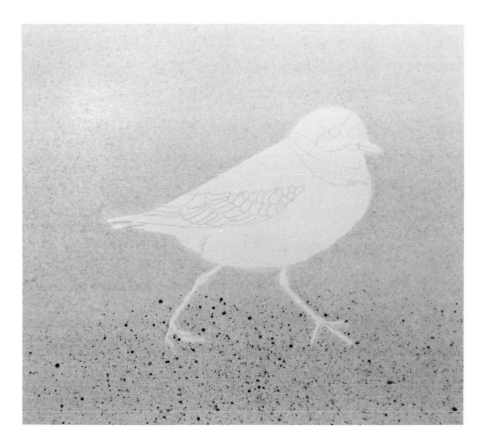

The tracing is carefully positioned over the white area and the details of the drawing are transferred.

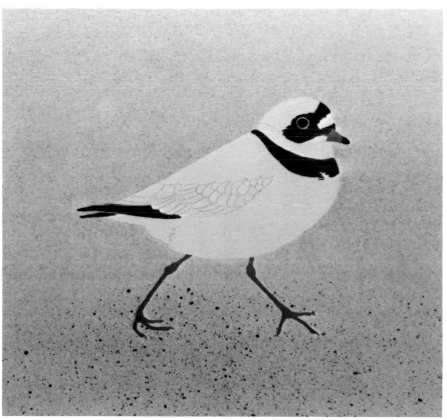

Opaque colors are painted on the dark head and breast markings, primary feathers of the tail, bill, and feet. On these areas the colors cover the white of the board completely.

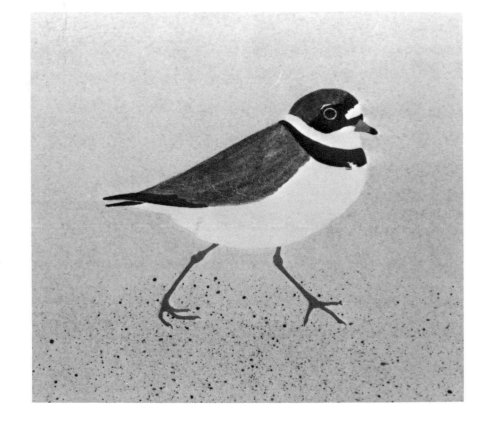

The head, back, and wings are moistened with clean water and a thin wet-in-wet wash is applied over these areas. This gives a lighter, less-dense look than an opaque color. The traced feathers of the wing should show through the wash; if not, transfer them again.

Feather edges on the back/scapular area are suggested by gentle tipping. The edges of the wing feathers are detailed with a light opaque color in the #1 round brush.

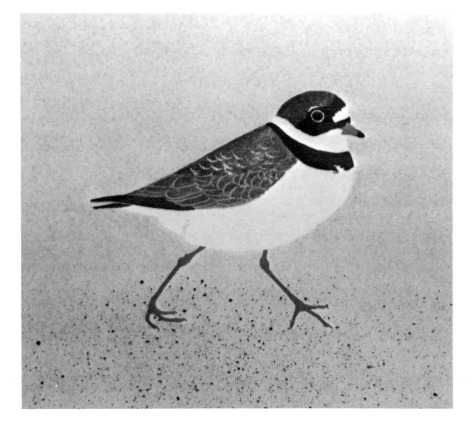

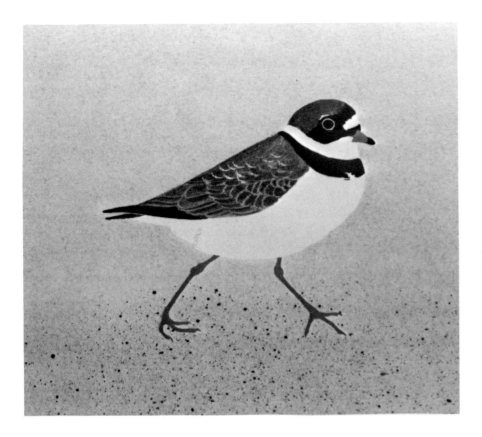

A more concentrated solution of the same color used on the back and wings is painted under the edge of each wing feather. Then, using a clean, damp brush, lightly blend the light margin and dark area of each wing feather. This gives shape to the feathers.

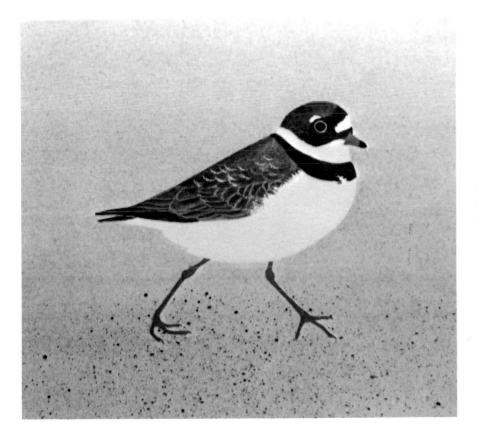

Opaque white is painted over the light patterned areas of the head, neck, and body, and the small white patch above the eye is enlarged. Additionally, thick opaque white is splitbrushed over the leading edge of the wing to indicate the tucking of the wing into the body feathers.

A shadow area on the sand is shown with a thin, dark, quick wash. The shaded area on the throat is indicated by glazing over the area lightly, then blending the edge of the shadow as it wraps around the throat. To show shadow and form on the body, a dark wash is glazed over and graded into the white. This is best accomplished by turning the picture upside down, loading the brush with thinned color, and, starting at the undertail coverts and edge of the belly (the darkest areas), slowly glaze the dark color over and blend it into the white. About a quarter of the way into the shadow area, clean the brush and pull the dark color into the white until the light and dark are blended. This blend need not be even and perfect. To achieve a blend the white may also be worked back into the dark.

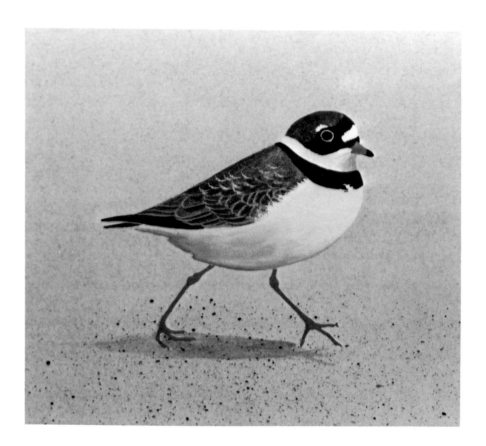

White and the shadow colors are used alternately with a splitbrush on the breast and flanks to add shape and impart a lightly feathered look. Since the legs and one foot are in shadow, a thin dark color is washed over the opaque color already applied.

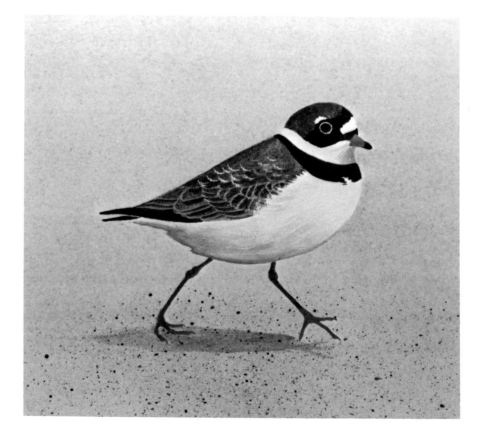

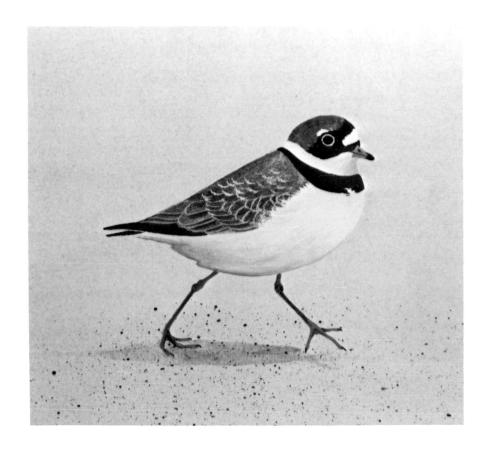

The dark nostril and bill are detailed with a #1 round brush, which is then used to paint the small webs on the feet and the toes.

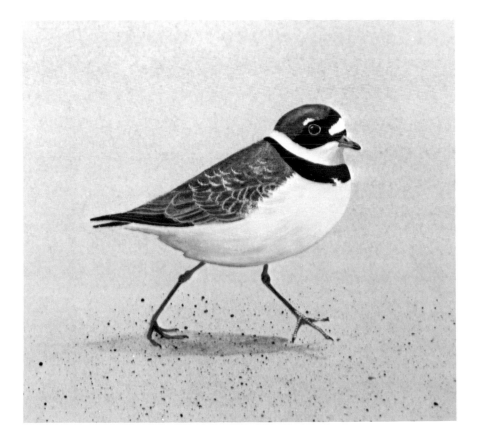

Light highlights are painted on those toes that are not in shadow. The highlighted areas on the bill are detailed with a hard line, which is then softened slightly with a clean, damp brush. The edges of the primaries are detailed with a light color. The eye ring is defined by making the surrounding dark edge more regular. Finally, a curved highlight is placed in the eye and the semipalmated plover is complete.

6
Describing
Shorebirds

 There are many types of shorebirds, from plovers to sandpipers to avocets, and each has its own particular behavior patterns and physical characteristics. In addition, shorebirds have the widest variation between breeding and nonbreeding plumage and between adult and juvenile plumage than does any other order of birds. Most of the plumage changes, as well as some leg-color changes, occur during specific months; thus, when painting backgrounds for shorebirds, the subject matter must represent the proper time of year for an accurate painting. To complicate matters even more, shorebirds are often seen during molt, which means a combination of breeding and nonbreeding plumage. Also, feather wear may be extensive, which can alter the shape of the feathers, their patterns, and the shape of the bird itself. All of these variables may seem daunting, but they really aren't. Familiarize yourself with the attitudes, habits, and seasonal characteristics of the individual shorebird you wish to paint, and get started.

Body Feathers

The body of a bird is covered with feathers that fall into groups with specific names. These names are important for identification and for descriptive purposes in following the steps in the painting examples. Though the color and shape of the feathers are important, they can also reflect behavior by how loose or tight against the body they appear, which affects the basic shape of the bird.

Parts of a shorebird.

Notice the scapulars: In this illustration they are pulled back tight, exposing the top of the wing and indicating that this adult bird is alert. Smaller, well-defined scapulars may, in some cases, be typical of juvenile plumage. The upper-back area is referred to as the mantle; its patterns and definitive form make it distinct on shorebirds.

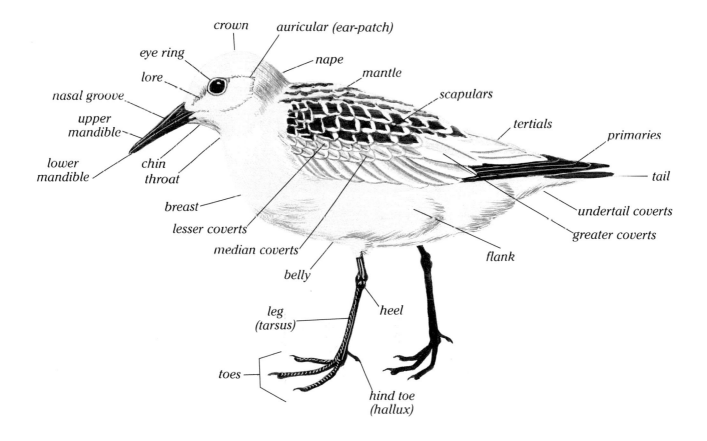

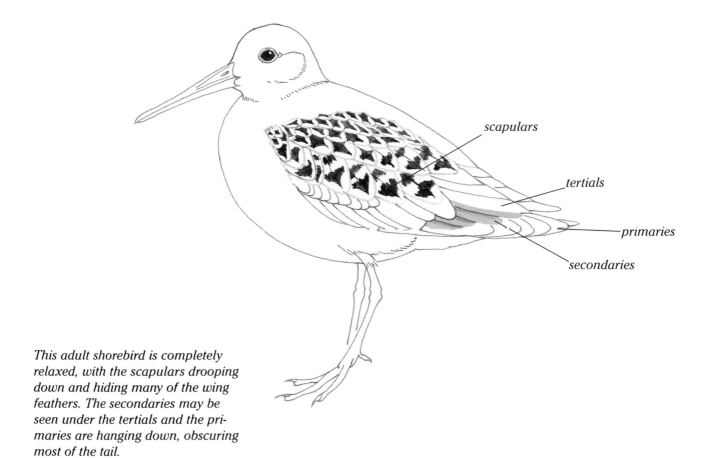

scapulars

tertials

primaries

secondaries

This adult shorebird is completely relaxed, with the scapulars drooping down and hiding many of the wing feathers. The secondaries may be seen under the tertials and the primaries are hanging down, obscuring most of the tail.

Three attitudes of a knot: 1. resting, warming in the sun; 2. alert, feathers tight, neck extended; 3. neck pulled in, relaxed, feeding.

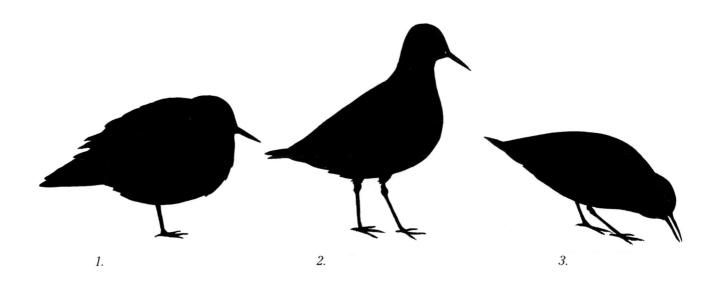

1. 2. 3.

Feet and Legs

There is a wide variety of feet, leg, and leg-scale type in shorebirds. The feet tend to be uniform by group. The sandpipers have a hind toe (*hallux*), except for the sanderling, which has none. The plovers generally have no hind toe, but if one is present it is very small. The toes may be webbed or not, and the phalaropes have lobed toes. The legs of shorebirds may be covered with scales that are *reticulated* or *scutellated* (shingled).

The "heel" of the leg is usually visible. This is the joint of the leg that bends backward and is often, mistakenly, called the knee. When drawing the heel it is important to remember that this is a joint where the swollen ends of two bones articulate. Thus, the contour of the joint can change depending on the degree of bend in the heel. The scaly covering of the heel may be stretched tight across the joint, may be compressed and form wrinkles, or may be loose, outlining the ends of the two bones.

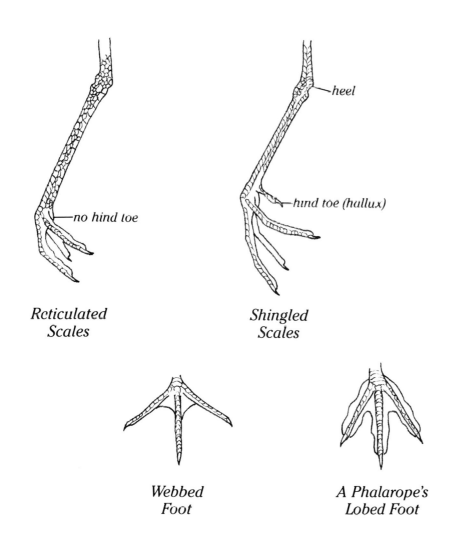

Reticulated Scales

Shingled Scales

Webbed Foot

A Phalarope's Lobed Foot

Because shorebirds have large bodies in proportion to their long thin legs, proper placement of the legs where they meet the body is crucial or the bird will appear to be severely off balance. This is especially true when painting shorebirds that are standing on one leg, because in order to maintain balance the center of gravity must be over the foot.

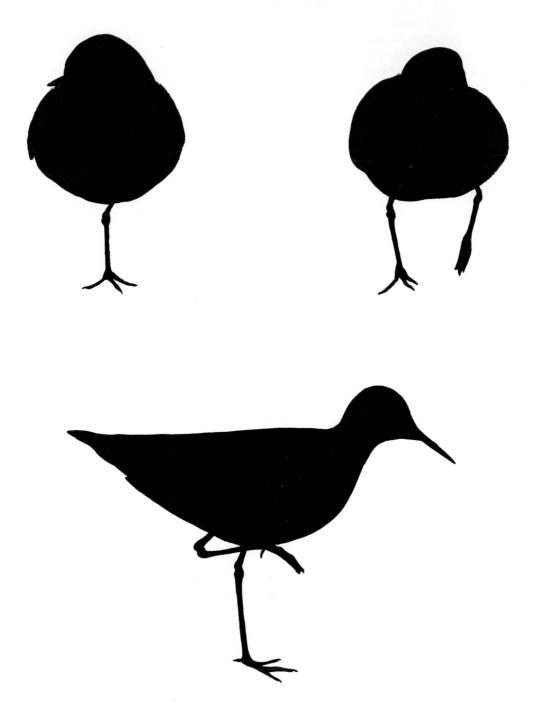

Bills

Many shorebirds have distinctively shaped bills: some long, some stout, curved up, down, or straight. A nasal groove is usually present on the upper mandible. A common error in bird painting occurs where a bird is shown eating or singing and the artist fails to realize that only the lower mandible moves. The upper mandible cannot move—it is fused to the skull. No matter the shape of the bill, the upper and lower mandibles when closed do not meet exactly on the edges. The lower mandible has a little curve to the edge that allows it to fit under the upper mandible. When painting the bill, you can show this curve by adding a thin highlight. Also remember that the top of the upper mandible is rounded—not razor sharp. Though bills come in many shapes and sizes, there is one way to paint all bills. For different shapes, additional highlights may be added or enlarged.

Using opaque color, the bill is painted in. Highlights are added with opaque white. Soften the edges of the highlights with a clean, moist brush.

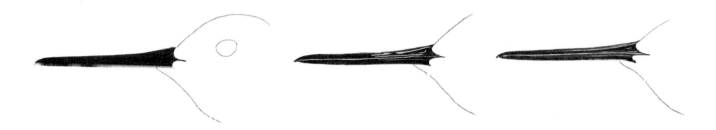

Eyes

The eye is a convex lens—not a flat disc on the side of the head. The lens extends inside the skull as well as out, which means that to accurately portray an eye, depth must be shown by a shaded area at the top of the eye and a highlight must be painted to show the outward curve of the lens. In many shorebirds the iris is a very dark brown that is indistinguishable from the black pupil. The eye in this instance appears all black, and a curved highlight on the lens must suffice to show the roundness of the lens. The pupil must appear in the center of the eye because bird eyes are fixed in their sockets and cannot "roll" as other animal eyes do.

The eye is not round but is slightly elliptical, although in some plovers it appears almost round. The eyes of most shorebirds, especially plovers, are large in relation to head size.

A thin color (the iris color) is painted over the entire eye. Opaque black is painted at the top of the eye to indicate shadow, and the iris is placed. After the black is dry, a clean, moist brush is used to dry-blend the shadow area downward. A curved highlight is added carefully with opaque white.

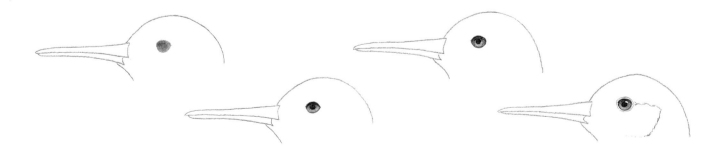

Wings

The feather groups of the wing have specific names and the feathers overlap one another in ways that are always consistent. Primaries and secondaries are easily counted; the proper number is of concern only when depicting flight because when at rest the feathers are tucked and not all of them are visible. This is especially true in shorebirds where the large tertials often hide most if not all of the secondaries. The greater coverts are distinct; however, the median and lesser coverts may be small and blend together with ill-defined edges. This is especially true with the small underwing coverts, often called the *wing lining*.

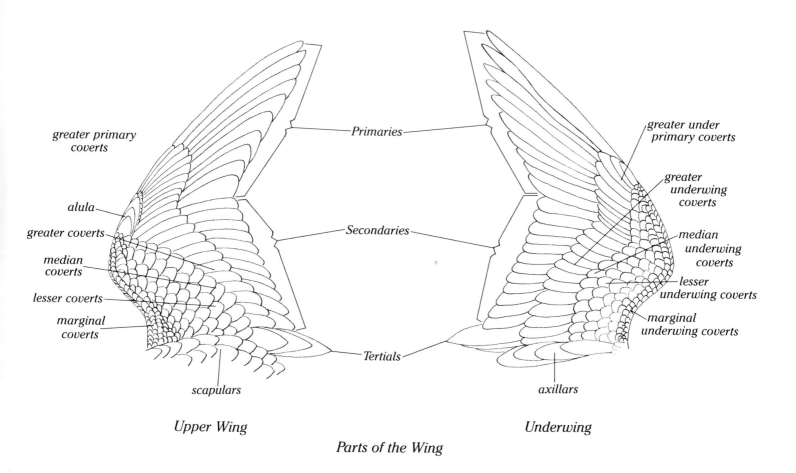

greater primary coverts

alula

greater coverts

median coverts

lesser coverts

marginal coverts

scapulars

Primaries

Secondaries

Tertials

greater under primary coverts

greater underwing coverts

median underwing coverts

lesser underwing coverts

marginal underwing coverts

axillars

Upper Wing

Underwing

Parts of the Wing

The wings of many shorebirds are designed for rapid powerful flight. They are characterized by a pointed shape, thin primaries, and large distinct tertials. Because of extensive use during long flights, the wing feathers may show extensive wear that is most evident on the larger feathers. It is interesting to note that the lighter-colored parts of a feather abrade faster than do the darker areas. When painting shorebirds it often creates a more interesting effect to depict slightly worn feathers than to show them in pristine condition.

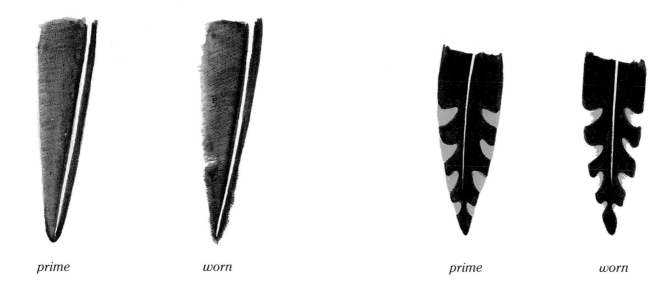

prime *worn* *prime* *worn*

Primary Feather **Tertial Feather**
(lighter-colored parts worn first)

Painting a primary feather. The illustration shows not only the fundamentals of painting a large primary, but the shading indicates that the feather has *camber* (curvature), which is essential to flight.

To paint: The front of the feather (above the shaft) is given an even coat of color. The back of the feather is dampened thoroughly and a graded wash is applied, working from the shaft down. Then, the splitbrush technique is used to indicate feather barbs. Last, surface color is painted back into the feather to indicate breaks that occur between the barbs.

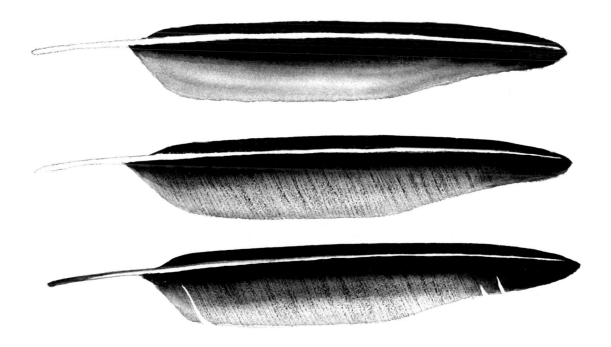

Tails

Compared to other groups of birds, the tails of many shorebirds are rather small, whether in flight or at rest. Naturally, the tail is important during flight and is used during landing, but a large tail is not as critical for most shorebirds, which land on relatively flat surfaces, as it is for birds that land and balance on perches. There are exceptions, one being the upland sandpiper, which lands on perches and has a large tail.

The shape and number of tail feathers are variable in shorebirds, and the end contour may vary from round to pointed to almost squared. When at rest the tail feathers are usually tightly tucked together and only a few are visible, even when they are not obscured by the primaries. The upper-tail coverts are rarely visible when a shorebird is at rest.

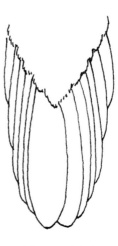

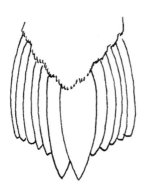

Plover tail, top view. Sandpiper tail, top view. Not all sandpipers have the two pointed central feathers.

Plover Tail

Sandpiper Tail

7
Painting
Examples

Random Notes Prior to Painting

As you follow along with the painting examples, you will notice that at times certain adjustments are made to the picture in color, value, shape, or whatever. This is the way a picture actually progresses; changes are always being made. These examples were not prepainted and then done again for this book. These are first-time examples, done so that you could see the real process of a bird picture being painted, corrections and all. Very little may be learned from watching the painting of a flawless picture.

Plan ahead when beginning a painting; have only those brushes, colors, and materials you will need at hand. Excess tubes, brushes, and whatever only add clutter when you need it least. Although the colors on your palette initially look organized when first squeezed out, don't be dismayed when it all seems a mess after a short time. Very few artists maintain a controlled palette. Have a scrap of watercolor board handy to test brushes for load and stroke, and a rag or paper towel to blot brushes. Give yourself clean water, brushes, all the other painting stuff you'll need, and time to paint.

The following painting examples were done on cold press illustration board and the paints are gouache (designers colors). Winsor & Newton and Pelikan brands are used interchangeably, except in the case of raw umber, where the brand used will be noted. Pelikan raw umber has less yellow than does Winsor & Newton raw umber. Painting examples are not life-size.

Ruddy Turnstone

Arenaria interpres

The appeal of these chunky little sandpipers lies in their striking coloration and determined behavior during feeding. In breeding season their chestnut-colored backs and wings, orange legs, and stark black-and-white markings make them distinct, whether on the ground or in flight. Even in their more drab nonbreeding plumage the dark bib retains its basic shape, enabling the most casual observer to easily identify them. Relentless in pursuit of food, they are often seen among the rocks probing in cracks or flipping over stones with their stout bills. On sandy beaches they congregate near piles of washed-up seaweed and other debris to dig and root for food. When feeding heavily or when tired after a long flight they may be approached rather closely, but when startled or wary they move quickly, their sturdy legs enabling them to run well, and when in the air they are strong fliers, able to move out of range with ease.

When you are painting the ruddy turnstone, getting the basic patterns and colors presents no particular problems; the main thing to be aware of is that there is very little definition of individual colored feathers on the back, scapulars, and wing. Thus, there is a tendency to overpaint individual feathers. Also, the number of black scapulars and the black pattern on some of the wing feathers and tertials is variable—some have more black, some have less.

The palette used is: raw sienna, burnt sienna, Winsor & Newton raw umber, ultramarine blue pale, cadmium red pale, ivory black, and white. The brushes used are #3 and #1 Kolinsky rounds. Unless specifically noted, the #3 round is the brush used.

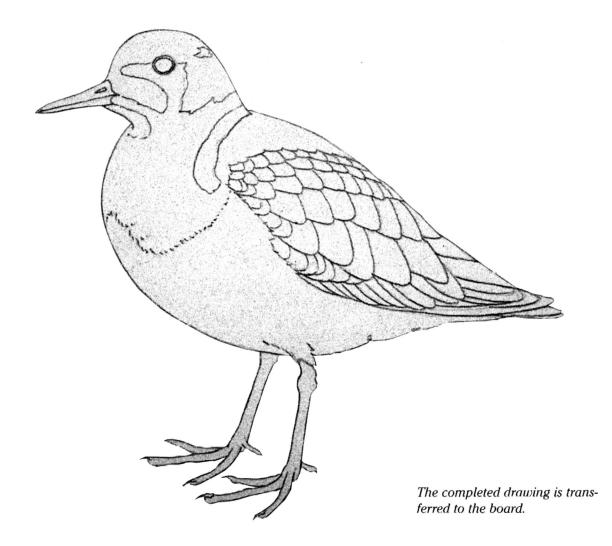

The completed drawing is transferred to the board.

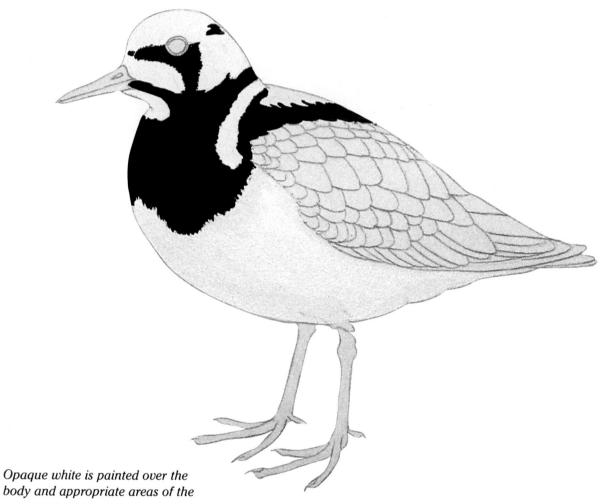

Opaque white is painted over the body and appropriate areas of the head and throat. When the white is dry, opaque black is painted onto the bib of the breast, head, and mantle. The edges of the black are painted with the tip of the brush to give a feathered look instead of a hard edge.

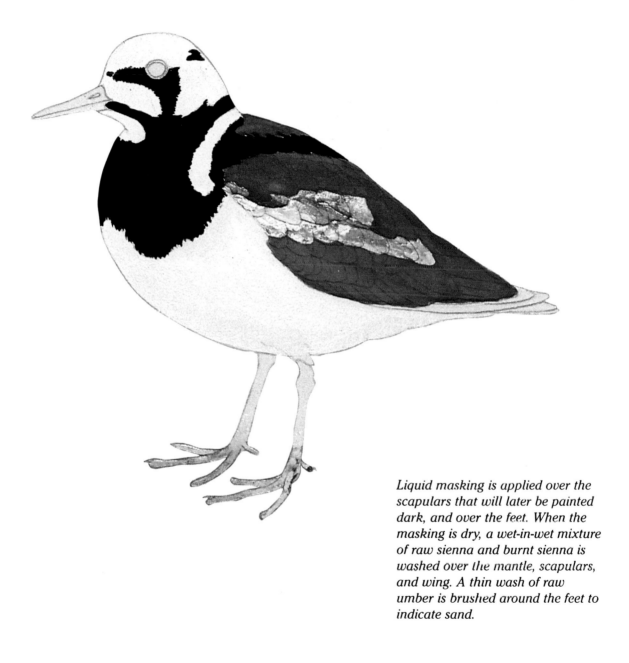

Liquid masking is applied over the scapulars that will later be painted dark, and over the feet. When the masking is dry, a wet-in-wet mixture of raw sienna and burnt sienna is washed over the mantle, scapulars, and wing. A thin wash of raw umber is brushed around the feet to indicate sand.

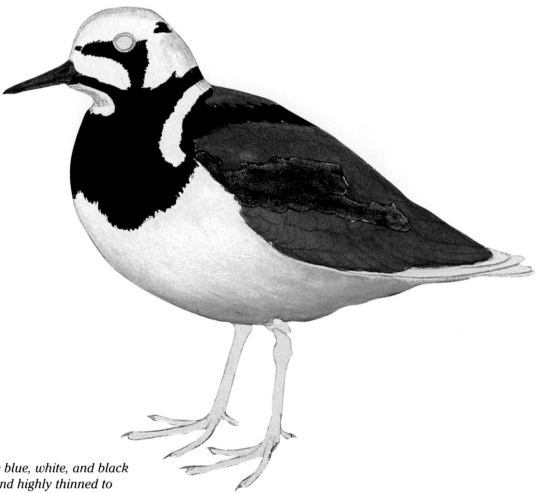

Ultramarine blue, white, and black are mixed and highly thinned to create a shading color. Then, starting at the rear of the belly, glaze over the flanks and belly by slowly pulling the color forward with a clean, damp brush. You may have to brush back and forth between the white and the shading color to achieve a blend; however, in this case the blend may be rather rough. Additionally, the shading color is drawn up the breast with the tip of a clean, damp brush—this separates the breast from the background. The head, neck, and throat are also lightly glazed with the shading mixture. The masking is removed from the feet and scapulars. A wash of very thin black is brushed over the bill and those scapulars originally covered by the masking.

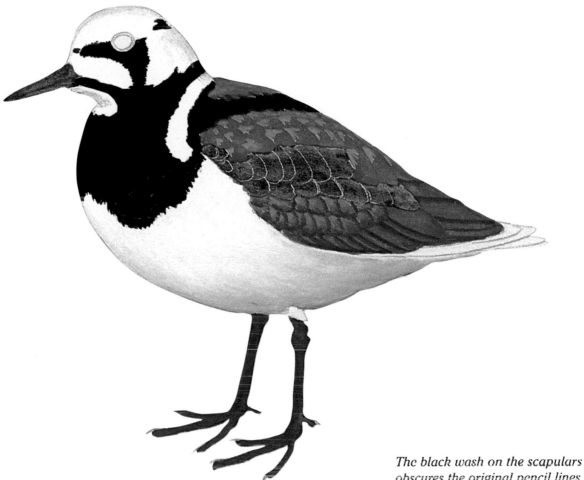

The black wash on the scapulars obscures the original pencil lines, so they are retransferred. The legs and feet are painted in with a mixture of burnt sienna, raw sienna, and cadmium red. Shading of the chestnut-colored feathers is begun by painting the base of the feathers with a thin mixture of raw sienna, burnt sienna, and white, as seen on the scapulars. Then the edges of the feathers are painted with a darker mixture of raw sienna, burnt sienna, and raw umber, as seen on the wing coverts. These two color mixes are then blended using a clean, damp brush. This dark mixture is used to separate the tertials and greater coverts by painting a thin line under each feather.

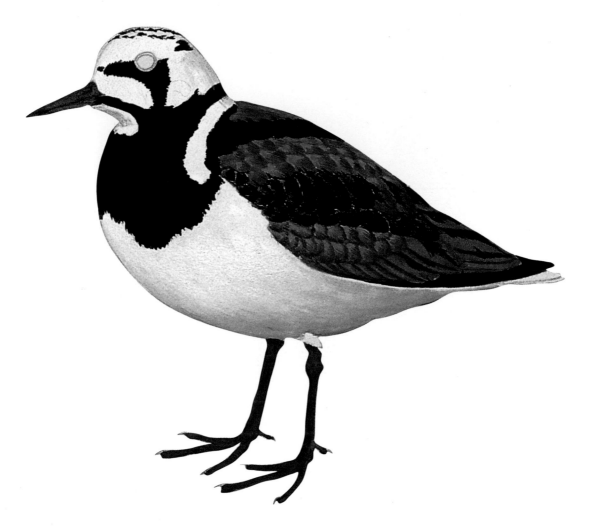

Following the procedure for the wing coverts in the preceding step, the chestnut scapulars are completed. Opaque black is used to outline the edges of the black scapulars; notice the feather edges are irregular. This black on the edges is then coarsely graded back into the feathers to create a dark but not totally black feather. Opaque black is also used to paint the pattern on the crown of the head and for the markings on the tertials, some scapulars, and wing feathers.

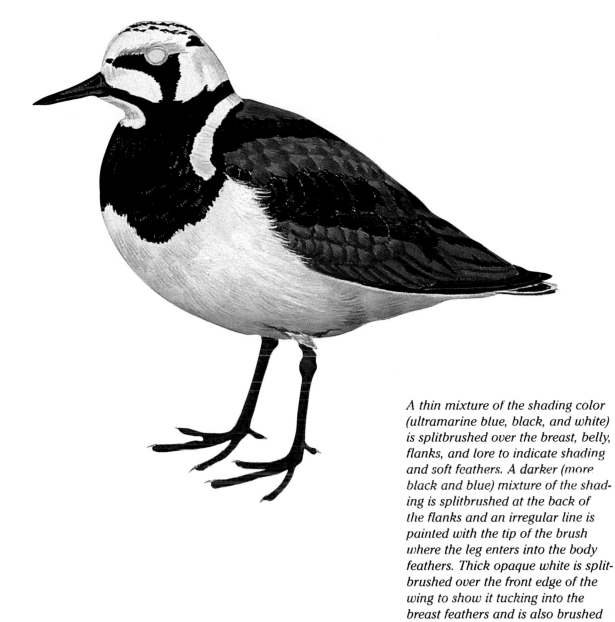

A thin mixture of the shading color (ultramarine blue, black, and white) is splitbrushed over the breast, belly, flanks, and lore to indicate shading and soft feathers. A darker (more black and blue) mixture of the shading is splitbrushed at the back of the flanks and an irregular line is painted with the tip of the brush where the leg enters into the body feathers. Thick opaque white is splitbrushed over the front edge of the wing to show it tucking into the breast feathers and is also brushed over some of the shading color to indicate light feathers. A thin mixture of white and ultramarine blue is tipped and splitbrushed on the black bib to indicate feathers, and the same mixture is used with the #1 round to paint the edges of the primaries. Opaque black is roughed in on the dark areas of the bill with the #1 round. Opaque raw umber is used to indicate scales and shadow on the legs and feet.

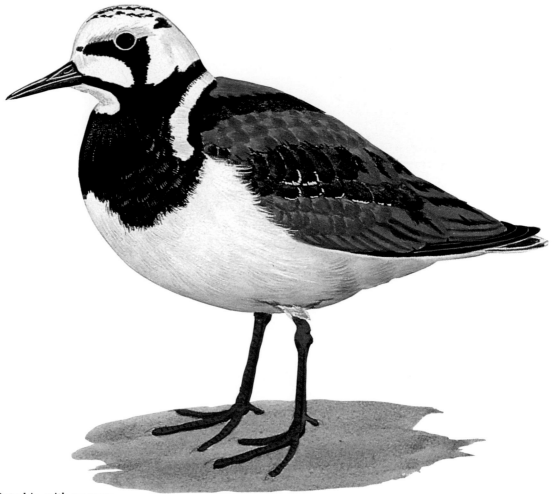

The eye is painted in with opaque black, which is then used to place the dark central pattern on the tail feathers. These feathers are then outlined in gray to separate the white margins from the background. The black on the bill is blended with a clean, damp brush, and the bill highlights are roughed in with opaque white, which is also used to add light margins to some of the black scapulars. The number of scapulars that show white varies. It is determined that the edges of the chestnut-colored scapulars and wing coverts are too light, so a mixture of raw sienna, burnt sienna, and raw umber is glazed over them to make them darker.

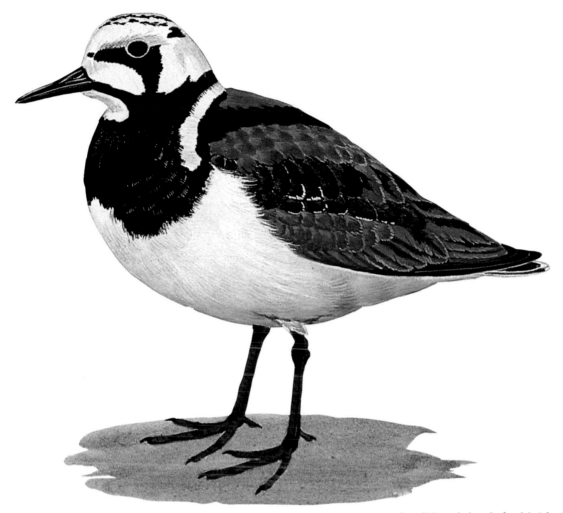

A splitbrush loaded with black is brushed over the bottom edge of the black bib to soften it and indicate softer feather edges. The white highlights on the bill are blended and refined with a clean, damp brush. A #1 round is used with thinned black to indicate the dark markings on the legs and feet and to paint in the nails. As some of the scapulars, tertials, and wing feathers get tattered, the edges fade and become lighter. To indicate this wearing, a mixture of white and raw sienna is detailed on the margins with a #1 round, which also is used to paint in occasional feather splits with opaque black.

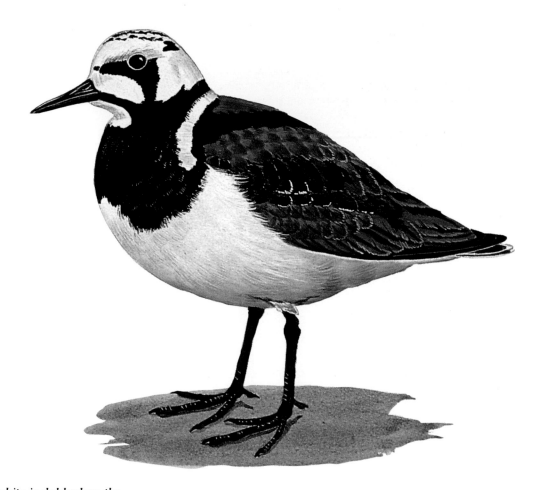

Thinned white is dabbed on the
scales of the legs and feet to suggest
highlights. A light shadow is painted
under the toes with thinned black.
Feather vanes are detailed on the
wing coverts using the unthinned
chestnut mixture. Finally, a curved
highlight is placed on the eye and
the ruddy turnstone is complete.

Lesser Yellowlegs

Tringa flavipes

Because they are similar in appearance if not in size, the lesser and greater yellowlegs are the downy and hairy woodpeckers of the shorebird world. Unless seen together in order to compare size, they can be difficult to distinguish. The greater yellowlegs's bill is longer and slightly upturned, and the lesser's is shorter and straight. However, at distances that characteristic is hard to determine. Smaller size and feeding behavior are the best identifying features of the lesser yellowlegs. It was chosen as a painting example because it is quite common and has the interesting patterns and muted colors typical of many shorebirds. Often seen in flocks, they wade the shallow ponds and backwaters with a high-stepping leg action. As they search for food they snap and jerk at the water and mud rather than probe the bottom.

From a distance the lesser yellowlegs looks rather nondescript with spotted dark upperparts, a light-colored body, and yellow legs. It is only when the bird is seen up close that the distinct patterns of the feathers emerge. The larger wing feathers are distinct but the lesser coverts and scapulars blend together without much individual definition. The degree of patterning on the head and neck and the impression of lightness or darkness may vary from one yellowlegs to another. Because the patterns are rather complex, a preliminary drawing was done and the individual feather patterns were examined and sketched schematically. The painting example shows full breeding plumage. The nonbreeding plumage is lighter and more gray; in some birds an occasional gray feather will remain among the darker breeding colors.

The palette used is: ivory black, Pelikan raw umber, white, raw sienna, yellow ochre, cadmium yellow pale, and ultramarine blue pale. The brushes used are #1 and #3 Kolinsky rounds. Unless specifically noted, the #3 round is the brush used.

Painting examples begin on following page.

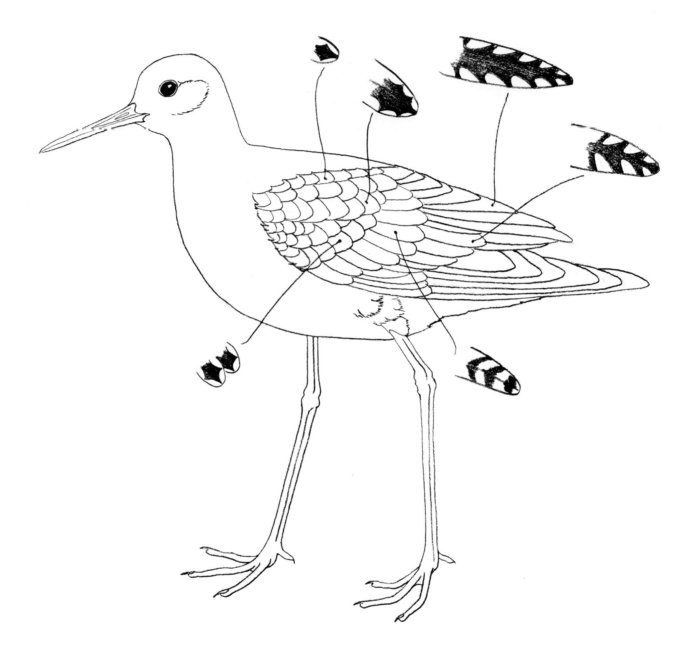

Preliminary sketch with feather patterns.

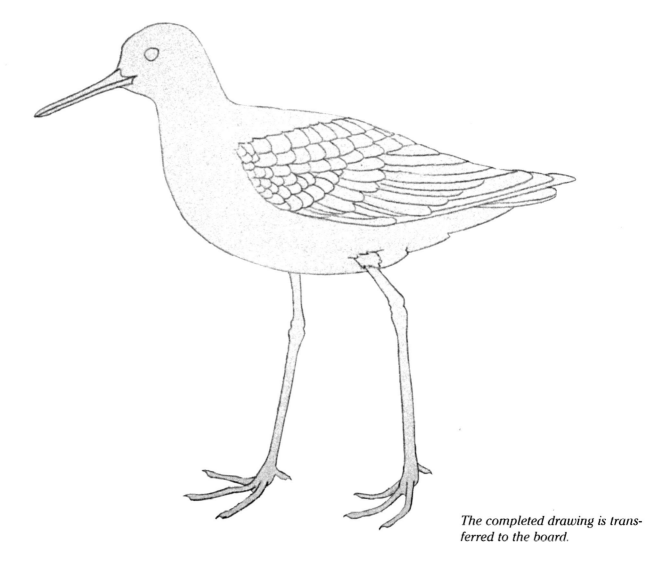

The completed drawing is trans-ferred to the board.

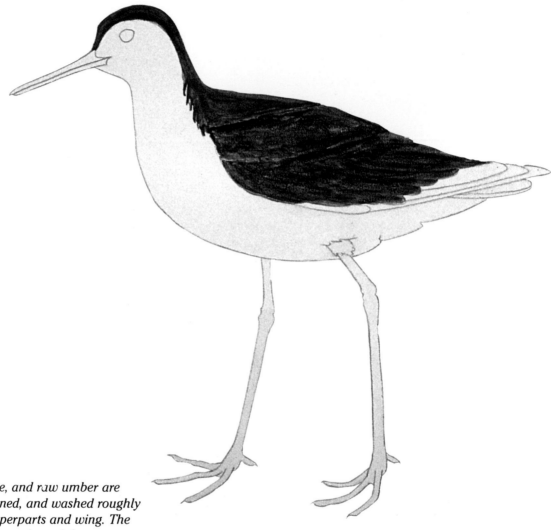

Black, white, and raw umber are mixed, thinned, and washed roughly over the upperparts and wing. The edges of the wash are left uneven. This wash need not be even because it will be broken up with patterns.

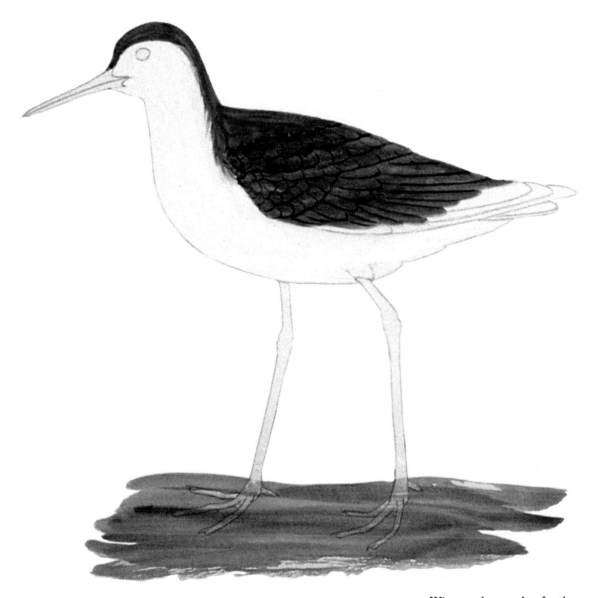

Wing and scapular feathers are outlined in black and the remainder of the head and body are painted in with opaque white. The feet are coated with liquid masking. When the masking is dry, a thin wash of raw umber and yellow ochre is brushed over the feet.

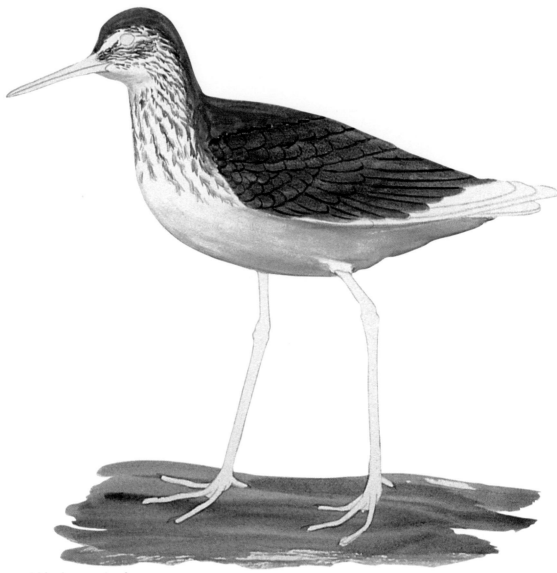

Raw umber and black are mixed and used opaquely to begin the development of the head and neck patterns. The tip of the brush is splayed slightly and short, irregular strokes give a natural, uneven look. Be careful to follow the direction of the feathers and contour of the body. The masking is removed from the feet. The picture is now turned upside down and, starting at the undertail coverts and belly, a mixture of ultramarine blue, white, and black is glazed and blended roughly into the white of the breast. Additionally, this shadow color is lightly glazed and blended on the chin and throat.

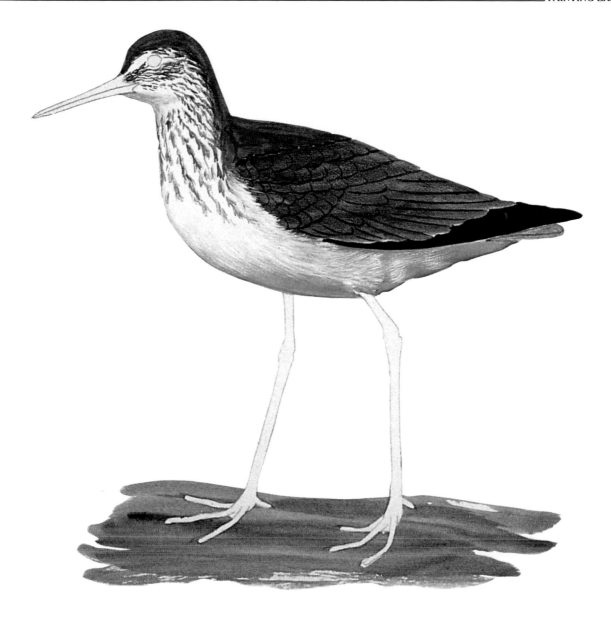

The primaries are painted with an opaque mix of black and raw umber. Opaque white is splitbrushed over the breast and flanks to suggest soft featheration and to show the wing tucking into the breast feathers. The tail is painted with a thin wash of raw umber and black. The feathers covering the top of the leg are shaded with the shadow color.

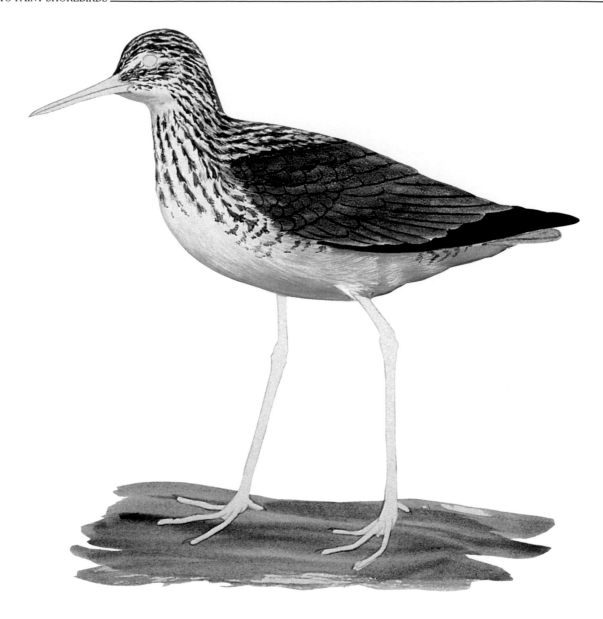

The leg feathers, previously described, are defined with opaque white. The head and neck patterns are refined and carried onto the breast and flank with the opaque black and raw umber mix. Opaque white is used, with the tip of the brush split slightly, to paint the feather pattern on the mantle and to work back into the dark neck and head patterns to further define them.

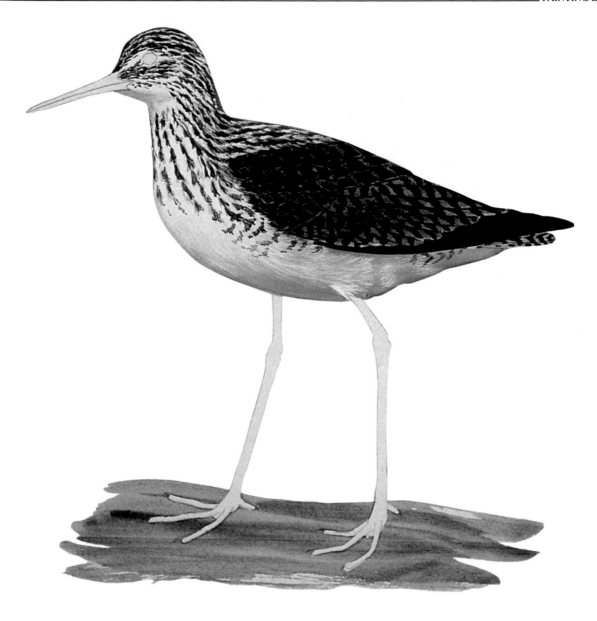

Referring to the schematic feather drawings on page 62, opaque black is used to detail the tail, wing, and scapular feather patterns.

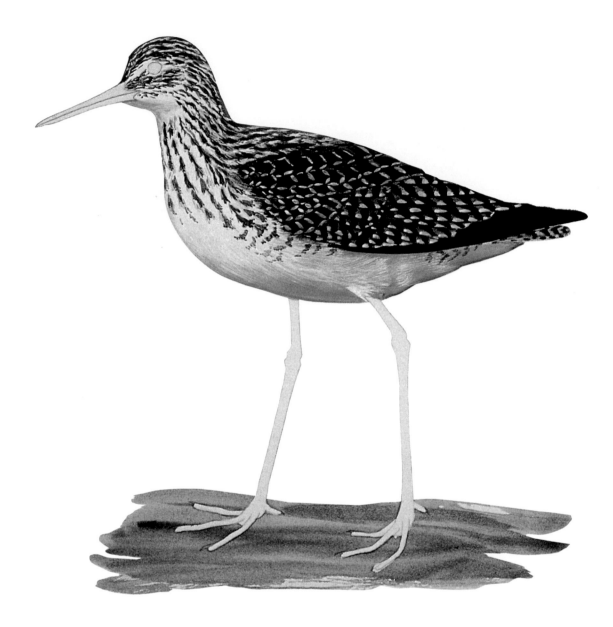

*White mixed with just a tiny amount
of raw umber is used with the #1
round to paint in the light patterns
on the scapular and wing feathers.
Opaque raw umber is splitbrushed
lightly over the black pattern
on some of the scapulars to give a
slight highlight.*

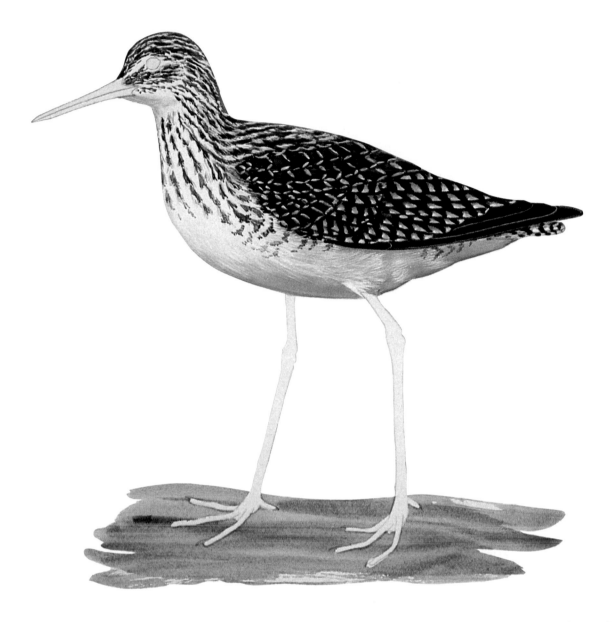

The mantle appears to be too light, so the raw umber and black mixture is worked back in to strengthen the dark pattern. The white pattern on the larger wing feathers is blended lightly up into the brown on each feather. This is accomplished by pulling the white up with a clean, wet brush. Thinned white is used to paint the patterns on the tail, and a thin black line is painted under each wing feather to further delineate them. A black and white mixture is used to detail the edges of the primaries.

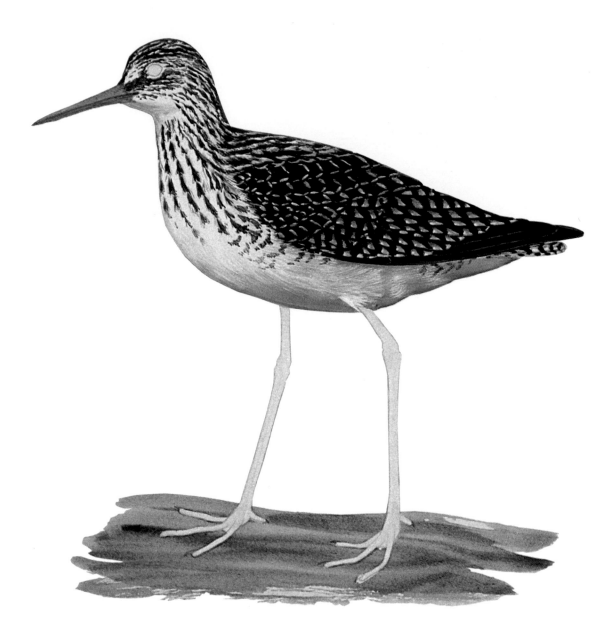

The patterns on the lore, crown, and
neck are refined by working
alternately with the black and raw
umber mixture, and white, until the
desired pattern and color is devel-
oped. The gray edges of the pri-
maries are blended back into each
feather by gently pulling the light
into the dark with a clean, damp
brush. The bill is washed in with
very thin black and the legs are
painted in with an opaque mixture
of cadmium yellow and raw sienna.

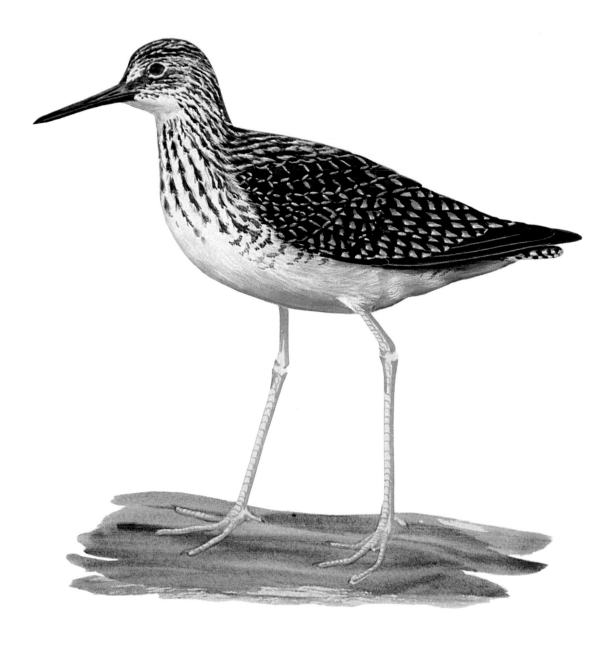

Opaque black is used to paint in the dark areas of the bill and to place a dark shadow line under each primary. The black is then used to indicate a shadow under the wing. This is accomplished by painting a line, then blending it into the body and over the tail. Thinned raw sienna in the #1 round is used to paint the shadows and scales on the legs and feet. Thinned raw umber is used for the pupil of the eye.

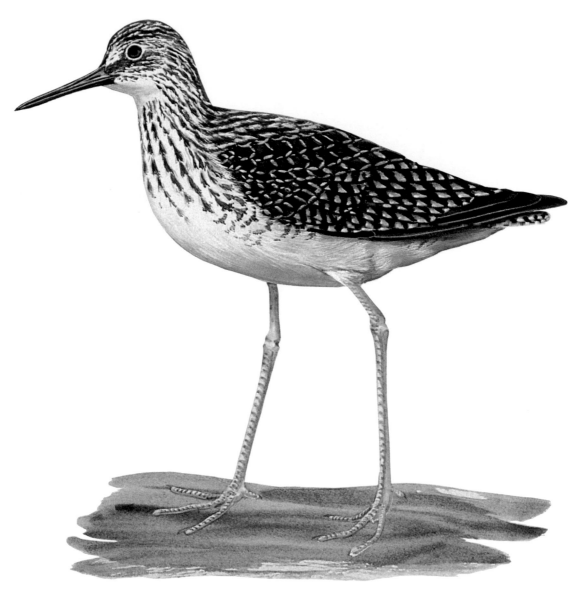

Thin raw umber is painted on the
shadow and scales of the legs and
feet to further accentuate them.
The black on the bill is blended and
rough white highlights are added.
Opaque black in the #1 round is
used to paint the iris and shadow in
the eye. The bluish body shadow
color is painted at the top of the leg
to show it entering the body.

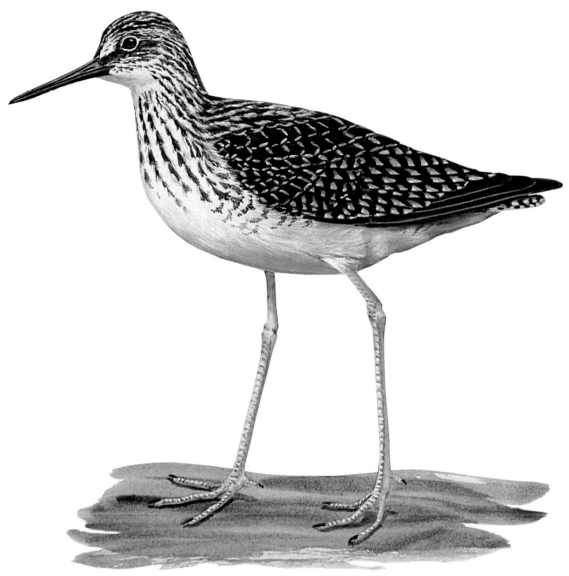

The edges of the hard white highlights on the bill are softened with a clean, damp brush and very thin white is dabbed on the leg and feet scales to show highlights. Opaque black is used for the nails on the toes and thinned black for the shadows under the feet. It is determined the eye shape is too round, so it is made more elliptical by reworking the white eye ring and black of the eye, with the #1 round, until the proper shape is achieved. The dark pattern around the eye ring is then touched up. Finally, the curved highlight is added to the eye and the lesser yellowlegs comes alive.

Killdeer

Charadrius vociferus

Without a doubt the killdeer is the most common and easily recognizable of the shorebirds. In winter it is seen close to water, but in summer it usually may be found far from water—on playgrounds, lawns, fields, golf courses, wherever there is an expanse of grass or gravel. This striking-looking plover could be called the urban shorebird. It walks about its territory briskly, stopping briefly to snatch up an insect or two, then off it goes again in constant search for food. It runs very well and when approached moves off quickly or takes flight with little hesitation. If its nest or young are near it performs its injured-bird act, leading intruders away from the nest area until all is well, then suddenly it has a miraculous recovery and flies away.

The double black band on the white breast makes a bold clean pattern, in contrast to the color of the back and wings, which can best be described as dirty brown. In breeding season these brown feathers are edged with a reddish or yellowish color. As the season progresses these colored margins are worn off, leaving plain, ragged brown feathers. The eye is quite large, with a red-orange eye ring, and the leg color can vary from straw- to flesh-colored.

The palette used is: lamp black, Pelikan raw umber, white, burnt sienna, ultramarine blue pale, yellow ochre, raw sienna, cadmium red pale, and cadmium yellow pale. Unless noted otherwise, the brush used is the #3 Kolinsky round.

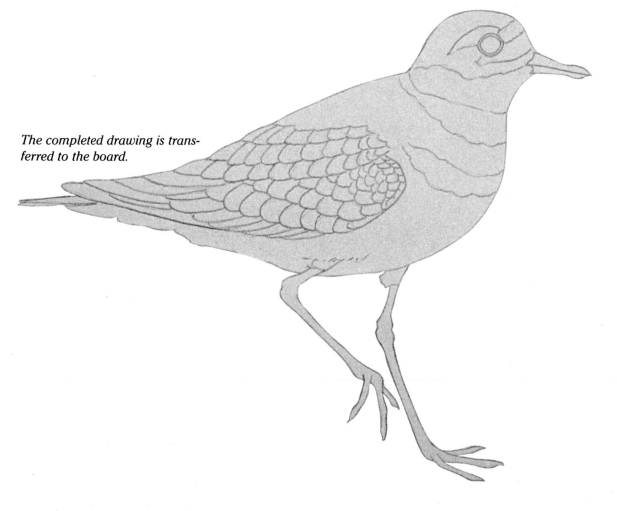

The completed drawing is transferred to the board.

Opaque black is painted on the head and breast features and the edges are detailed with the tip of the brush to give a feathered appearance. Thinned black is then brushed over the bill and primaries. Liquid masking is applied to the feet.

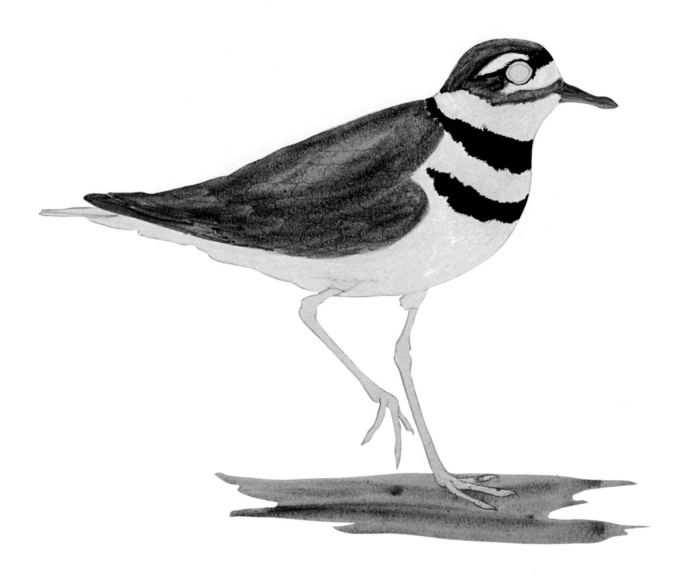

Raw umber and black are mixed for
the brown head, back, and wings,
and is washed wet-in-wet over these
areas. Raw umber and burnt sienna
are washed thinly around the feet
to indicate ground. Opaque white is
painted on the white areas of the
head and body.

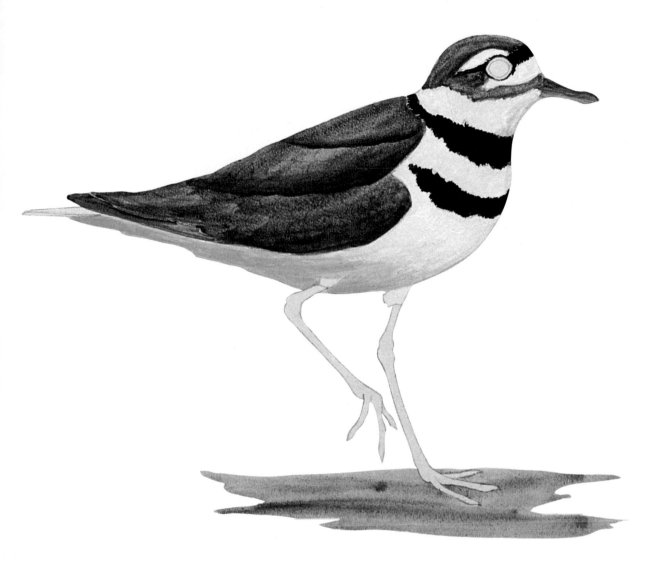

There are pronounced contours to the wing, scapular, and mantle areas. These are shown by glazing and grading a darker mixture of black and raw umber over each area separately. This is done by turning the picture upside down and, starting at the part to be darkest, painting on a line of dark color, then thinning and grading it into the brown with a clean, damp brush. If the shading is not dark enough, repeat the process. This same technique is used to shade the breast, belly, and throat, but with a mixture of black, white, and ultramarine blue. The masking is removed from the feet.

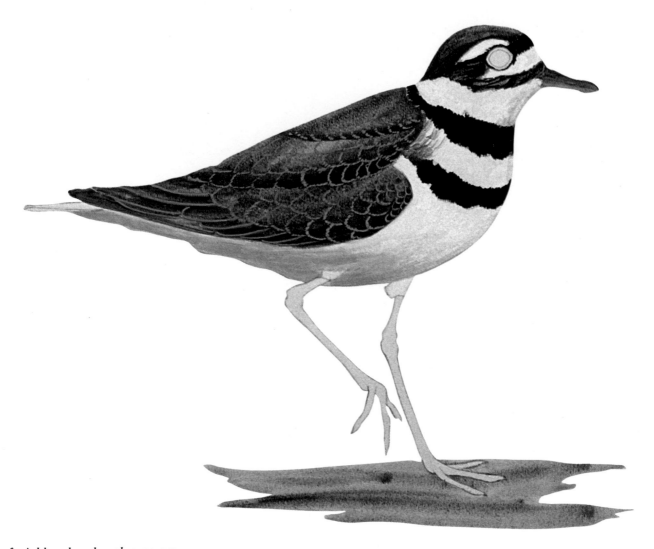

The facial band and neck area are developed by detailing thinned black in the #1 round. Yellow ochre is mixed with raw umber and lightly brushed at the back of the white breast band. Raw sienna, burnt sienna, and white are mixed and used opaquely in the #1 round to detail the edges of the brown feathers. Additionally, a black line is painted under each large wing feather to separate it slightly.

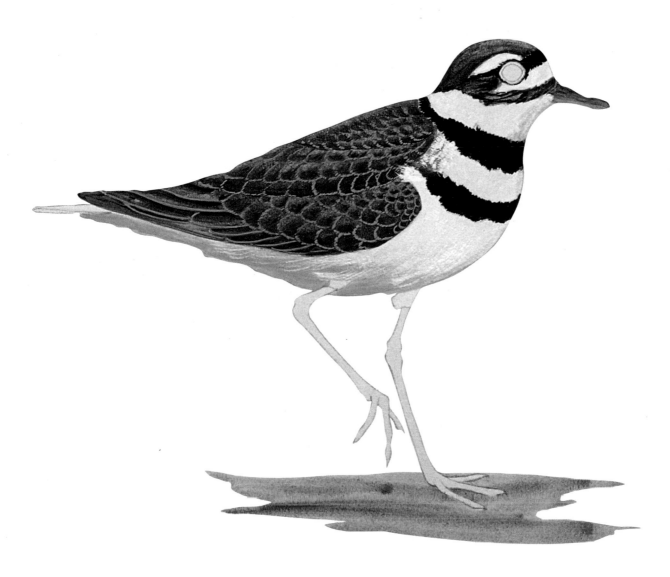

To relieve the flat look of the brown feathers and to further define them, a thin mixture of black and raw sienna is splitbrushed over the bottom part of each feather. Opaque white is used with the splitbrush to feather the breast, the flanks, and over the scapulars at the top of the breast.

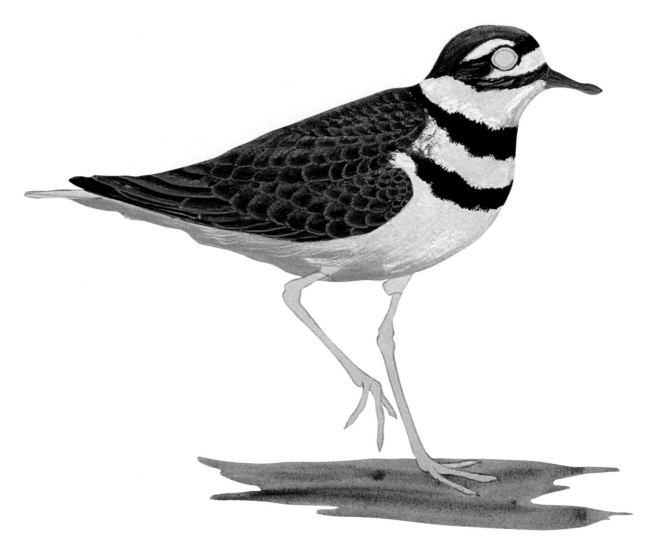

The light edges of the brown feathers are too harsh, so they are softened and blended into each feather by gently rubbing and pulling the light color into the brown; this is done with a clean, moist brush. Opaque black is splitbrushed on the edges of the black breast bands for a softer look, and is used with the #1 round to detail the primaries.

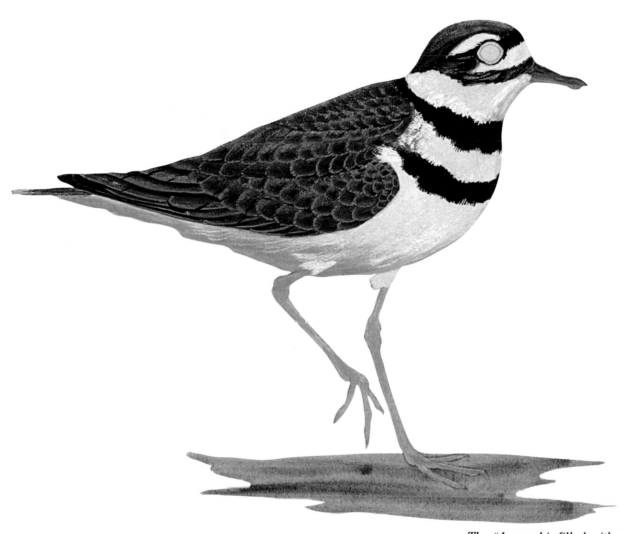

The #1 round is filled with opaque black and tiny shadows are painted under the bottom feathers of the scapular and mantle areas. This serves to further define and separate these features. A black shadow line is detailed under the tertials and primary coverts and an occasional random feather split is painted in. A base leg color of mixed yellow ochre, white, and raw umber is washed in. The tip of the tail is a mix of white and yellow ochre, which blends into a small area of burnt sienna. The remainder of the tail is the raw umber and black mixture. Opaque white in the #1 round is used to define the feathers at the top of the leg.

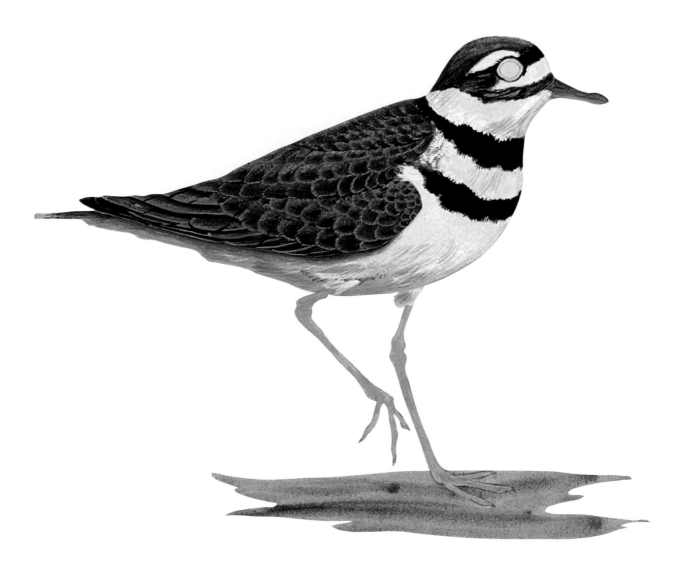

The wing is not tucked into the breast feathers but is held away from the body. To show this, a dark shadow mixture of black, ultramarine blue, and white is painted under the wing and graded down into the white of the body. The same dark shadow color is lightly split-brushed on the breast, flanks, leg feathers, and throat.

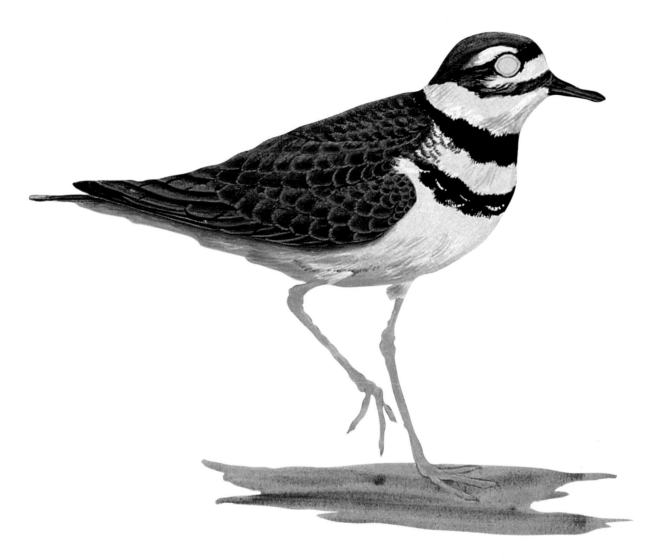

The #1 round is filled with opaque white and is used to enlarge the area above the eye and to indicate more white feathers under the eye. Yellow ochre mixed with burnt sienna is just touched into the white area above the eye. Opaque white is used with light tipping on the lower black breast band. Opaque black is painted on the bill and used to draw a thin line to separate the tail feathers. It is determined that the area where the white breast band meets the brown back is too indistinct and of the wrong color. Opaque white is painted over the area, and when it is dry, raw umber is tipped onto the area to achieve the correct look.

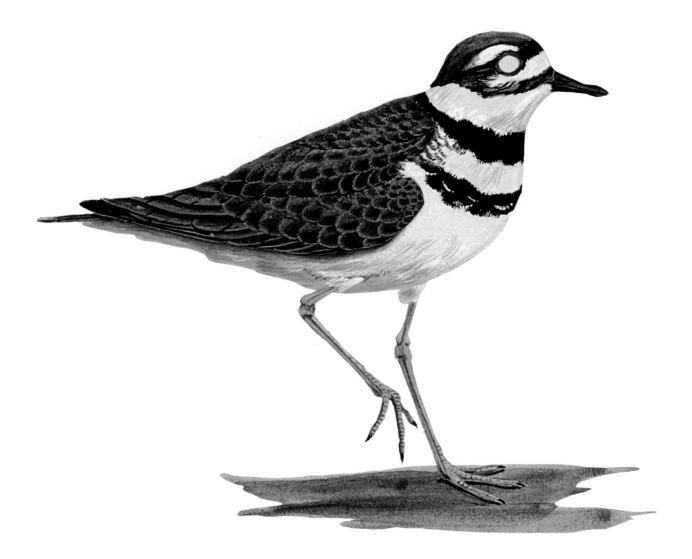

In most plovers the scales on the legs and feet are ill-defined, thus they are indicated here only slightly with a raw umber and white mix, which is also used to show shadow and tendon detail on the legs and feet. Opaque black is used for the nails on the toes and thinned black is used for a shadow under the toes and to wash a thin shadow over the ground. The opaque black on the bill is blended. A mixture of cadmium red and cadmium yellow is used in the #1 round to paint in the eye ring.

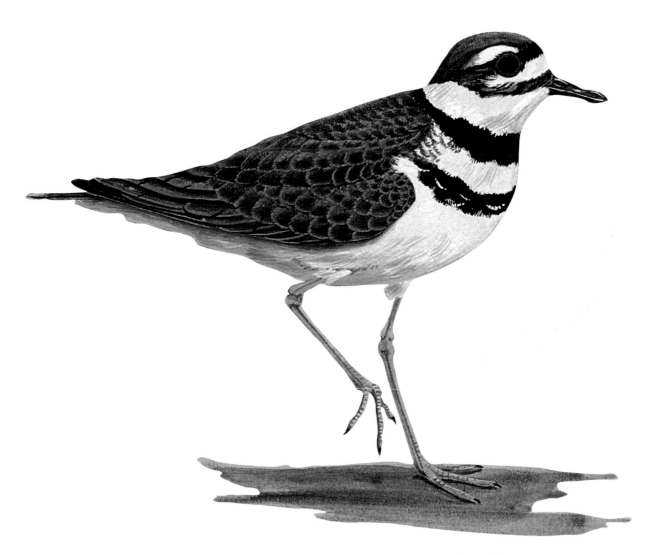

Opaque white highlights are roughed in on the bill, and very thin white highlights are dabbed on the scales of the raised foot. The eye is painted in with opaque black.

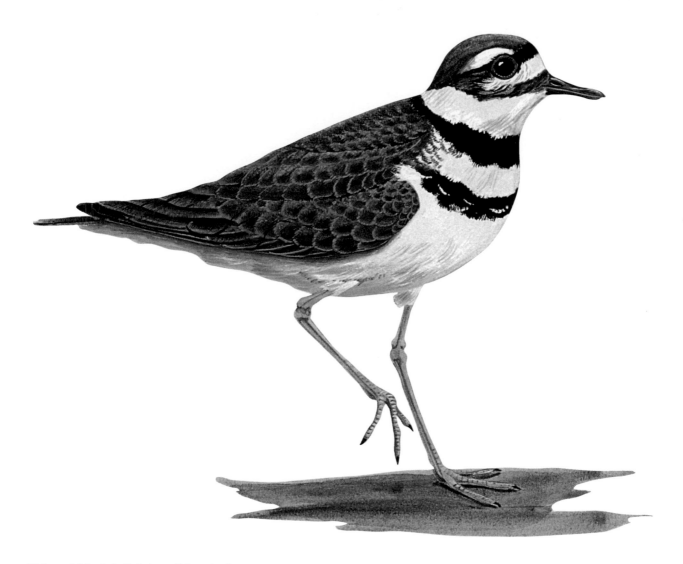

Thinned black is lightly splitbrushed on the tertials to add detail. The edges of the rough white highlights on the bill are softened. The white area in front of the eye is given some feather detail with the bluish shadow color. The little indentations in the eye ring are indicated with tiny black-and-white lines. The dark brown-black area at the base of the bill is enlarged slightly. The opaque white highlight in the eye finishes the killdeer.

8
Practice
Birds

Lesser Golden Plover

Pluvialis dominica

Because the lesser golden plover nests in the arctic tundra, it is rarely seen in its bold black-and-white breeding plumage. These birds are usually observed during migration in either juvenile or nonbreeding plumage, considered by many to be more beautiful than the summertime featheration. This plumage is comprised of rich blacks and subtle grays, with myriad golden and white spots. From a distance the spots seem rather random; however, on close examination definite patterns emerge. The color study sketch of a migratory lesser golden plover shows feather patterns and gives painting hints as well.

Palette: burnt umber, Winsor & Newton raw umber, ivory black, white, raw sienna, cadmium yellow pale.

Lesser Golden Plover (Rod Planck photo)

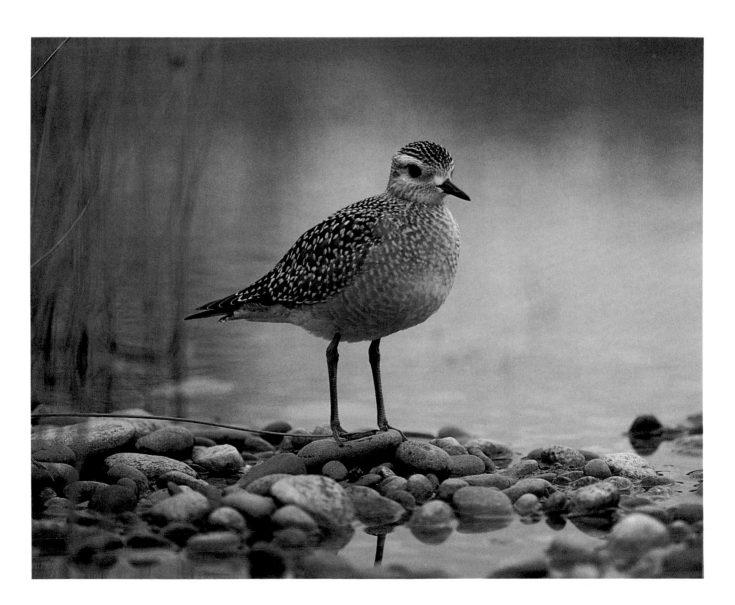

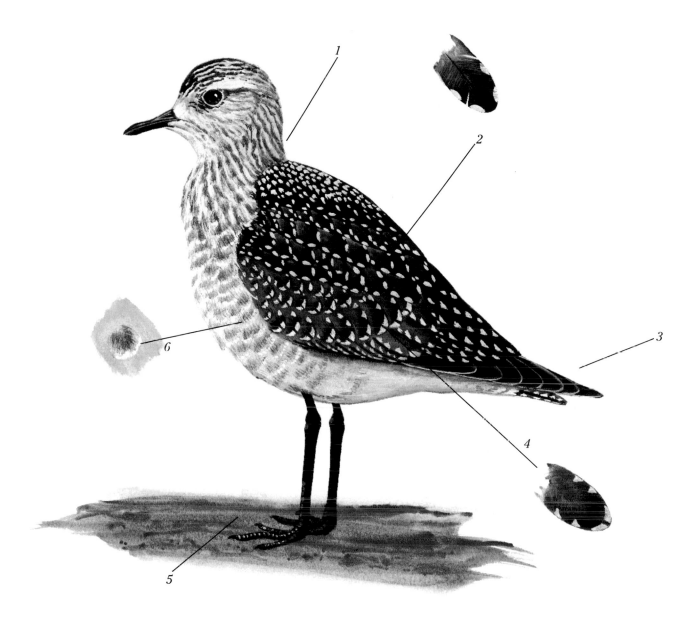

1. The base background color for the head and breast is a mixture of white, burnt umber, and a touch of black, applied in a wet-in-wet wash. The patterns are a mixture of ivory black and burnt umber applied with the tip of the brush, split slightly.

2. The basic color for the scapulars, mantle, and tertials is an opaque mixture of ivory black and burnt umber. The spots are an opaque mixture of raw sienna, cadmium yellow pale, and white.

3. The primary feathers are opaque ivory black detailed with white.

4. The coverts are a thin mixture of ivory black and burnt umber, and the tips are washed lightly with thin black. The spots are white with a touch of cadmium yellow pale.

5. The ground area is raw umber.

6. The breast feathers are split-brushed with a mixture of black and burnt umber. The feather tips are splitbrushed and dabbed with opaque white.

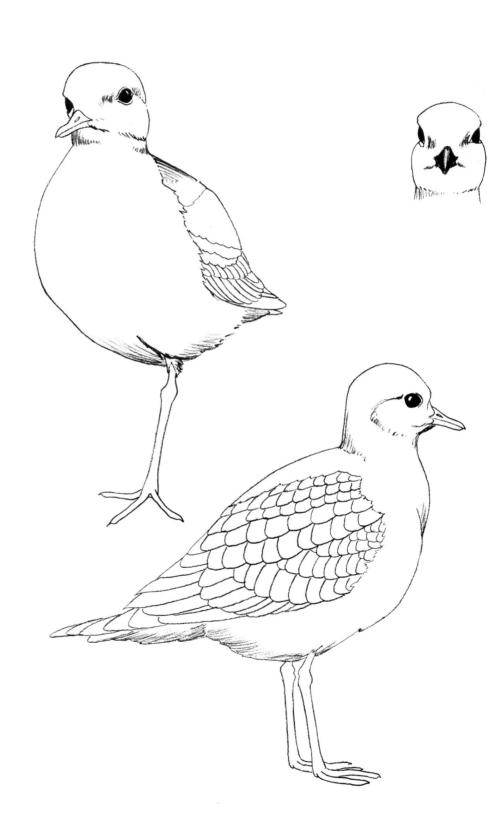

Lesser Golden Plover

Upland Sandpiper

Bartramia longicauda

Typically, sandpipers are associated with water. This is not the case with the upland sandpiper, which is usually found in grassland, perched on a stump or fence post. This bird has a long tail, by sandpiper standards, and its overall color impression, in the field as well as in photographs, ranges from a light gray-brown to a dark rich brown. Additionally, the feather edging may be almost white or brownish white. The color study sketch takes the middle road—it has the typical buffy color and medium feather edging.

Palette: ivory black, white, burnt umber, yellow ochre, and Pelikan raw umber.

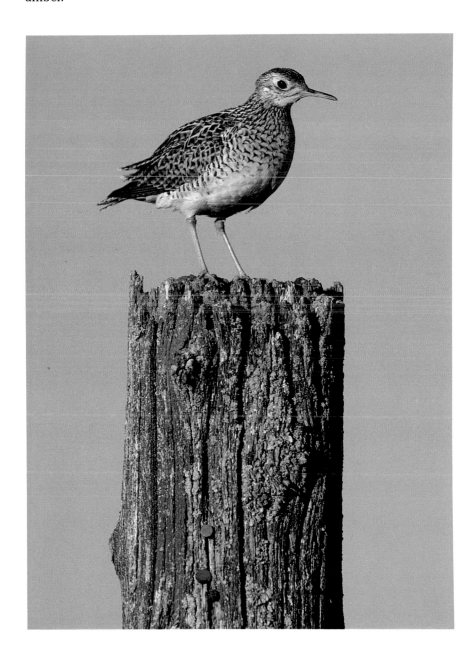

Upland Sandpiper (Rod Planck photo)

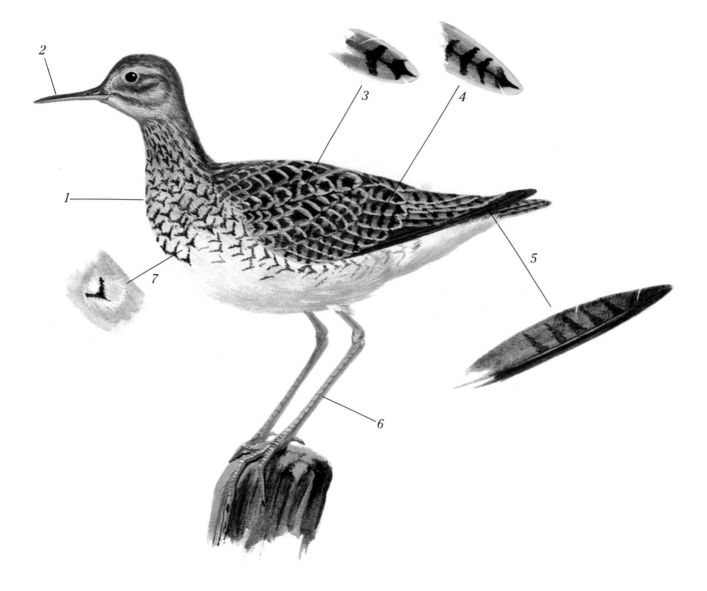

1. The buffy base color is a mixture of burnt umber, raw umber, and yellow ochre, applied as a thin wet-in-wet wash with each wash painted separately over an area. The areas to be washed separately are: first, the head-neck, then the scapulars, and finally the wing. This makes the washes easier to control.

2. The bill has a black upper mandible and a yellow ochre lower mandible.

3. The scapulars are done in the buffy base color with the center of the feather washed with a very thin coat of raw umber. The light edging is white mixed with raw umber, and the edge is softened. The barring in this example is black, but in some birds it is a dark brown. The dark barring varies somewhat from feather to feather.

4. The primary coverts are painted in the same manner as are the scapulars but the barring is more regular.

5. The primaries in the folded wing are an opaque mix of black and raw umber. An exposed primary shows the hidden barring.

6. Legs are yellow ochre and raw umber mixed. Opaque raw umber is used for the scales and shadows.

7. The black "V" is in the middle of a white breast feather when examined individually. All the white feather edges blend together on the breast.

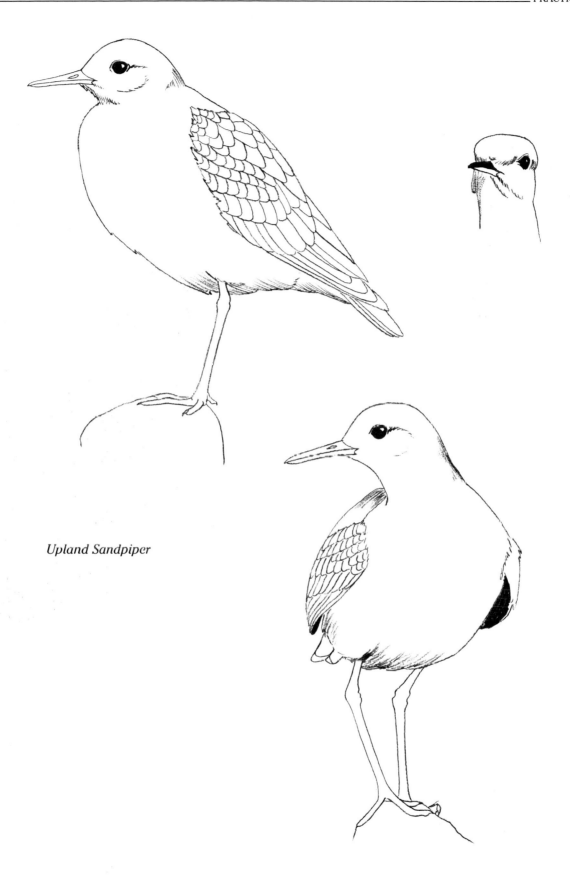

Upland Sandpiper

Dunlin

Calidris alpina

The dunlin is a shorebird that is instantly recognizable in breeding or nonbreeding plumage because the dark belly spot is always present. The breeding colors are especially distinctive not only with the belly spots but with rusty-colored black-patterned scapulars and tertials as well. The wing itself is not so brightly colored, being mostly brown and black. Occasionally, a drab nonbreeding feather will remain among the rusty-colored feathers throughout the breeding season. As feather wear increases, the edges become tattered and lighter in color. The color study sketch illustrates breeding plumage with only moderate feather wear.

Palette: burnt sienna, raw sienna, yellow ochre, ivory black, white, and Winsor & Newton raw umber.

Dunlin (Rod Planck photo)

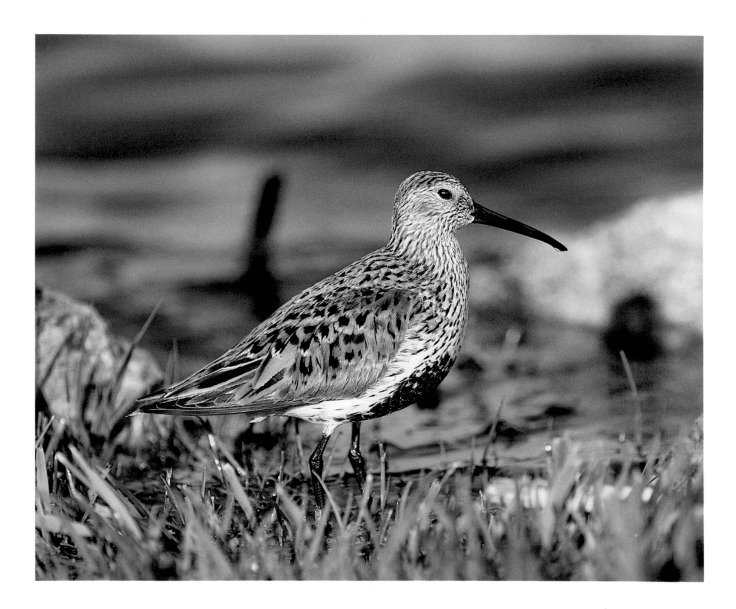

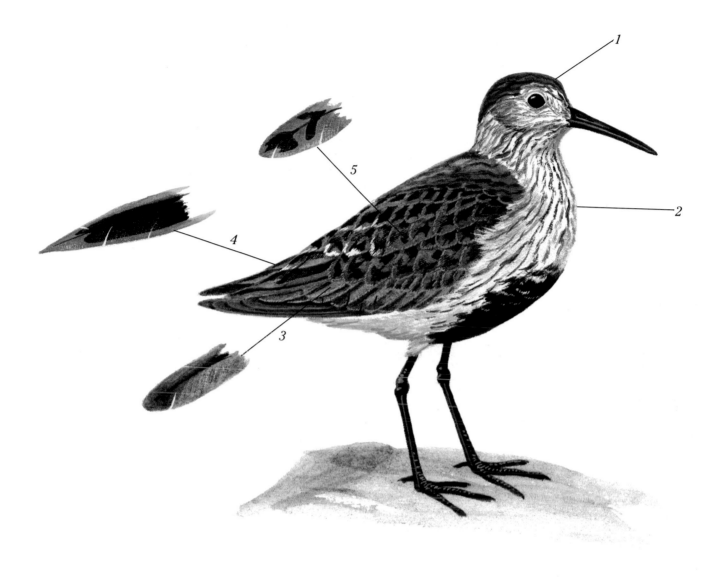

1. The rusty base color of the crown, mantle, scapulars, and tertials is a mixture of raw sienna and yellow ochre, painted with a thin wet-in-wet wash. Where a deeper rust shading is desired, a mixture of burnt sienna and raw sienna is used.

2. The opaque white breast is lightly splitbrushed with black to create the dark breast patterns.

3. Secondaries are painted with a mixture of raw umber and white, shaded with black.

4. The black pattern on the tertials is more regular than is the pattern of most of the other rusty feathers.

5. The black patterns on the scapulars are similar but inconsistent. The tattered light edging is indicated with a mix-

ture of yellow ochre, white, and a touch of burnt sienna, lightly splitbrushed or detailed with a #1 round. The number of scapulars with white edges varies from individual to individual.

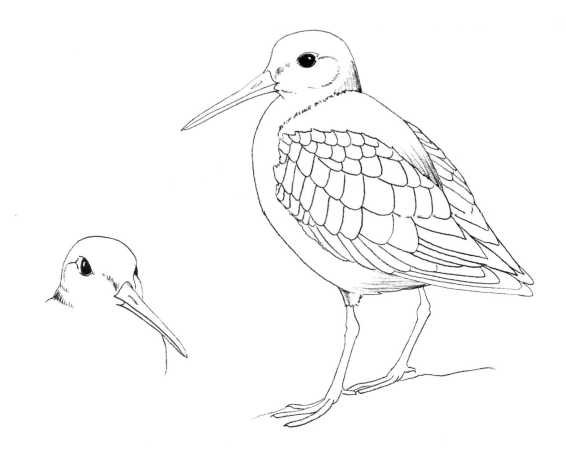

Dunlin

Solitary Sandpiper

Tringa solitaria

From a distance the solitary sandpiper appears rather undistinguished with its white-spotted dark upperparts and white underparts. A close look, however, reveals that this is an oversimplified description. There is a definite light and dark pattern to each wing and scapular feather, although because of rather indistinct feather edges the patterns blend together. The trick to painting the dark areas successfully is to paint enough feather-edge detail to show separation but not so much as to produce an overdone look.

Palette: Winsor & Newton raw umber, ivory black, white, and ultramarine blue pale.

Painting hints: The first and most tedious step is to concentrate on the separation of feathers in the wing and scapulars. A thin mixture of black, raw umber, and white is used for the dark upperparts, including the crown and tail. More black is added to this mixture and the resulting brown-black color is painted on the edges of each individual scapular and wing feather and then blended up into the feather. This gives just the right amount of roundness and separation to the feathers. With this same dark mixture, tip in feathers on the mantle. Opaque white is used to paint the white spots on the dark feathers and to paint the remaining light areas. The dark brown-black mixture and white are worked alternately on the head and neck for the proper patterns. A light mixture of ultramarine blue and black shades the white underparts.

Solitary Sandpiper (Rod Planck photo)

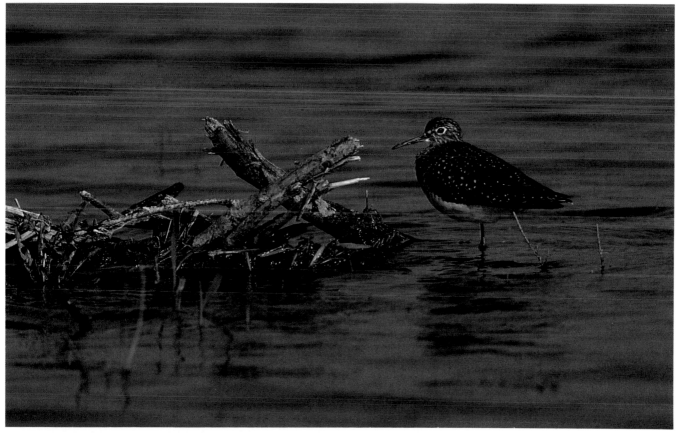

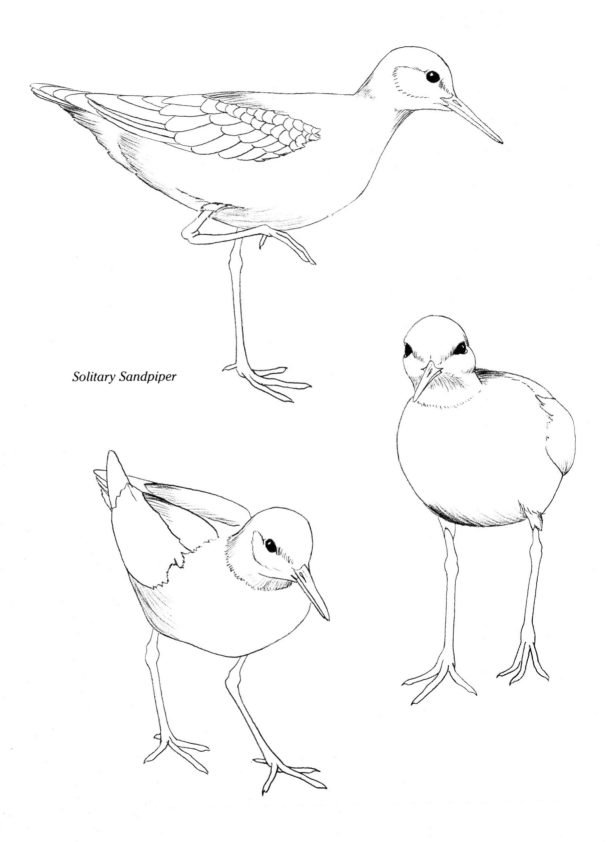

Solitary Sandpiper

American Avocet

Recurvirostra americana

With its distinctive shape, the American avocet presents no problem in identification. The black-and-white body coloration presents no problem for the artist either, except that the black areas are totally lacking in feather detail. Even the white tips of the scapulars and wing feathers are ill-defined and blend together to form irregular white bands. The shading of the head and neck may be somewhat tricky to mix, but by adjusting and testing the various proportions of burnt umber, burnt sienna, and cadmium yellow pale the correct color can be achieved.

Palette: burnt sienna, burnt umber, cadmium yellow pale, ultramarine blue pale, ivory black, and white.

Painting hints: Opaque black is used on the appropriate areas of the mantle, scapulars, and wing. Opaque white is painted on the underparts and light areas of the scapulars and wings. Where the black and white areas on the scapulars and wings overlap one another, the edges are splitbrushed to give an uneven feathered look. The head and neck color is a mixture of burnt umber, burnt sienna, and a small amount of cadmium yellow pale. The addition of more burnt umber to the base color will yield a darker shading color and the addition of white will give a light highlight color. Both the shading and highlighting are done with short splitbrush strokes. The leg color is a mixture of ultramarine blue, black, and white. This same mixture, thinned, is used for body shading. White is used to detail the head, and with the splitbrush is used to suggest feather highlights on the black of the wing.

American Avocet (Rod Planck photo)

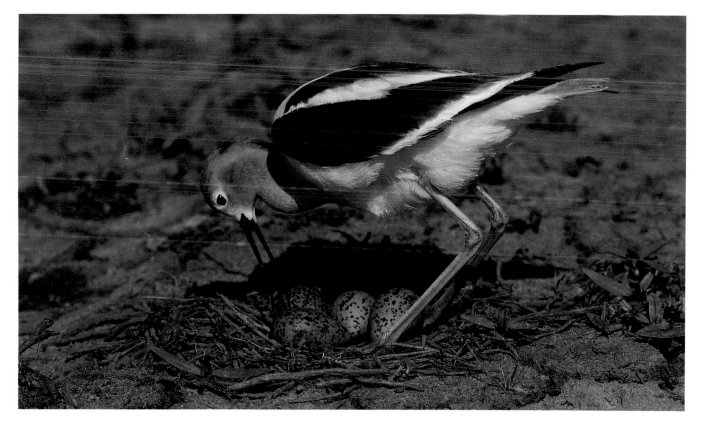

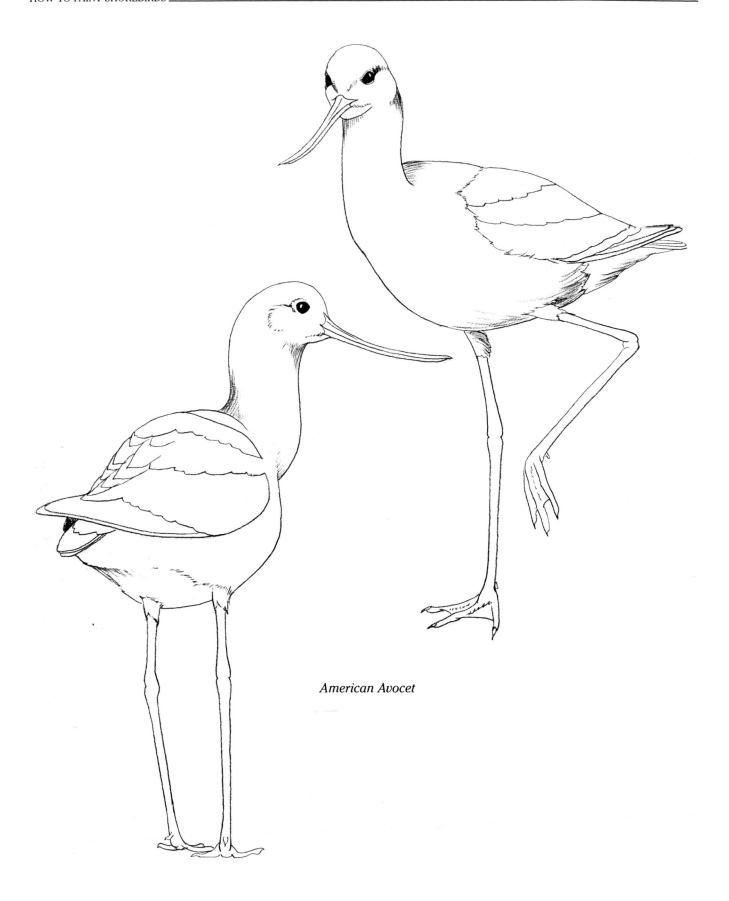

American Avocet

Whimbrel

Numenius phaeopus

This stately looking shorebird is a study in browns. The pattern on the wing feathers is distinct but does not contrast greatly with the lighter base-wing color. It would be wise to study and sketch these patterns prior to painting to insure their accuracy. The mantle and scapular feathers are rather indistinct except for the light spots on the margins. The lighter areas of the head and body are mostly light brown with only a minimal amount of white.

Palette: Winsor & Newton raw umber, burnt umber, ivory black, white, yellow ochre, ultramarine blue pale, and burnt sienna.

Painting hints: First the major color areas are washed in: the head and lower body with a thin mixture of raw umber and white; the mantle, eye line, crown, and scapulars with raw umber and burnt umber mixed; and the wing and tail with a mixture of raw umber, white, and just a touch of yellow ochre. The patterns are painted on the wing and tail with a thinned mixture of raw umber and burnt umber. This same mixture is used for the patterns on the head, breast, and flanks. Thinned black is painted on the primaries. White is used sparingly with the splitbrush to give a puffy, feathered look to the breast and flanks. Ultramarine blue is mixed with black for the color at the top of the gray-brown legs. Burnt umber and yellow ochre are mixed for the orange color at the base of the lower mandible.

Whimbrel (Larry West photo)

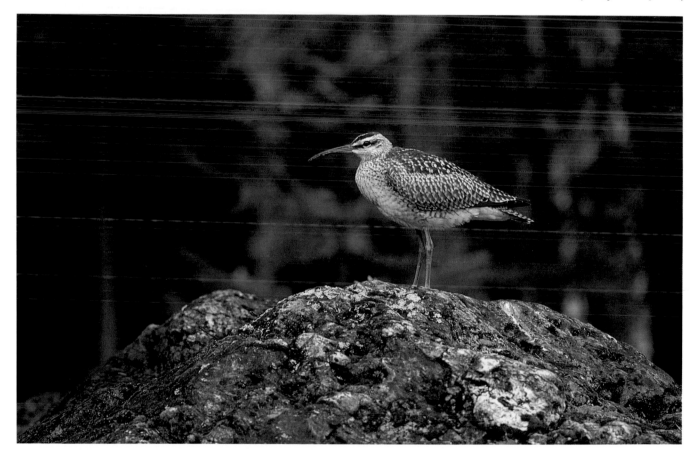

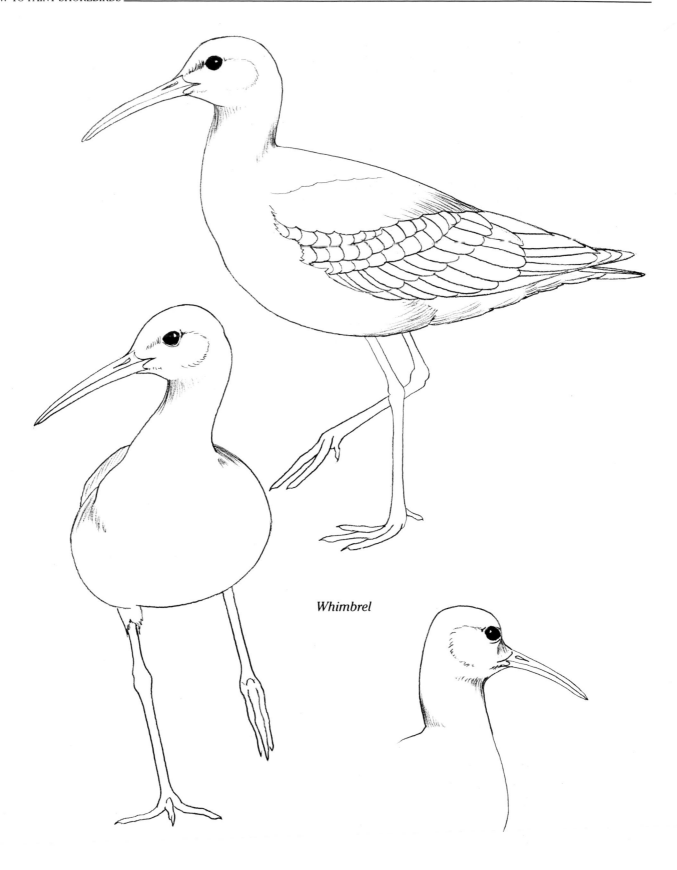

Whimbrel

Sanderling

Calidris alba

The photograph is of a sanderling in transitional plumage, and although it takes only a limited palette to paint a sanderling in this coloration, it will take quite a bit of time and patience to paint it successfully. This is because the pattern appears to be a simple one just of black and white. This is deceiving; there are many subtle shadings of gray, black, and white, with hints of brown on the head.

Palette: ivory black, white, Winsor & Newton raw umber, and ultramarine blue pale.

Painting hints: White, mixed with very small amounts of ultramarine blue and raw umber, is painted thinly over the entire bird, except for the eye, bill, and legs. This will give a light tint base that will enhance the pure white to be applied later. Using thinned black, work the dark patterns back from the head, neck, and onto the mantle, being careful to follow the contours of the bird. Next, paint the dark patterns on the scapulars with slightly thinned black. Black and white mixed to a medium gray is used on the wing feathers; this is where particular attention must be paid to the shading of the gray. The primaries are painted with opaque black. Very thin raw umber adds the brown to the head and neck. Opaque white is used to highlight the feather margins on the mantle, scapulars, and wing feathers. Additionally, the white is splitbrushed on the highlight areas of the head and body. The bill, eye, and legs are painted with opaque black.

Sanderling (Larry West photo)

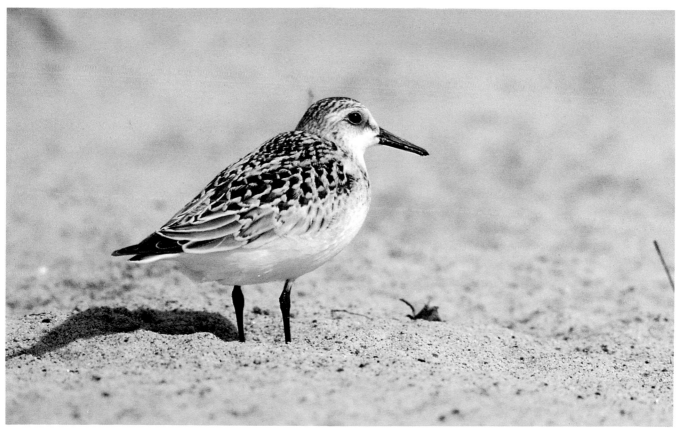

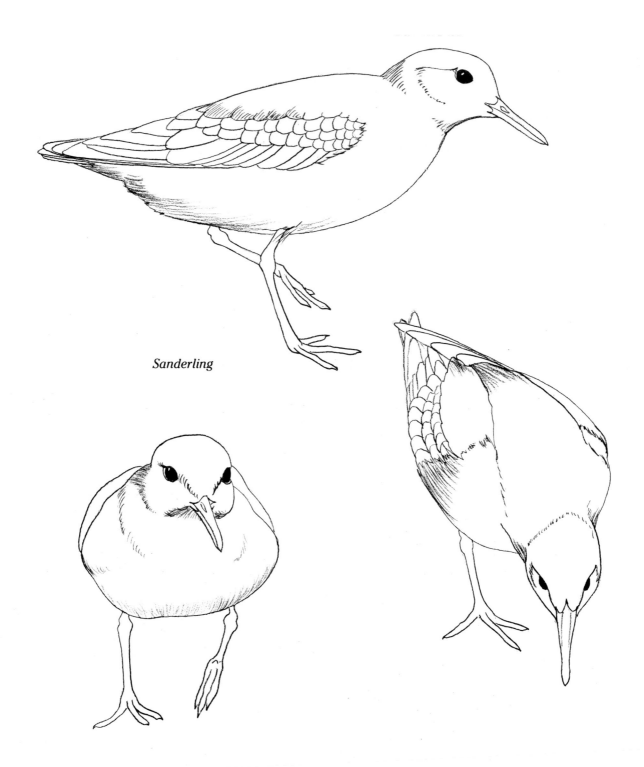

Sanderling

Wilson's Phalarope

Phalaropus tricolor

Phalaropes are distinct in at least two ways: first, they have a small head and a very chunky body; and second, the female is more colorful than the male. The photograph is of a female and was taken when the sun was at a low angle, giving her colors a very rich appearance. The brown of the wing feathers is edged with a yellow-brown where they have just begun to show signs of wear. Several of the brown scapulars are edged with a dark brick red, which, later in the breeding season, will fade considerably. The most difficult color to capture is the golden russet of the neck and flanks.

Palette: ivory black, white, cadmium red pale, burnt sienna, Winsor & Newton raw umber, burnt umber, yellow ochre, cadmium yellow pale.

Painting hints: The basic wing, tail, and scapular color is a mixture of raw umber, burnt umber, and black. The upper scapulars have a glaze of thin black over the brown base color. The brown-feather margins are detailed with a mixture of yellow ochre and cadmium yellow pale. The red on the scapulars is a mixture of cadmium red pale and burnt sienna. Opaque black is used for the eye line and back of the neck, and is then mixed with white to make the gray for the crown. The neck and flank color is a mixture of cadmium red pale, burnt sienna, and cadmium yellow pale. White is painted on the appropriate areas and blended with the neck and flank color where they meet. Black on the eye, bill, legs, and feet finishes the Wilson's phalarope.

Wilson's Phalarope (Rod Planck photo)

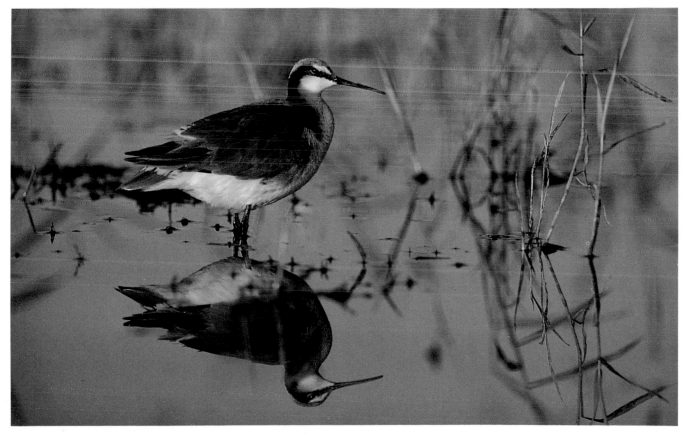

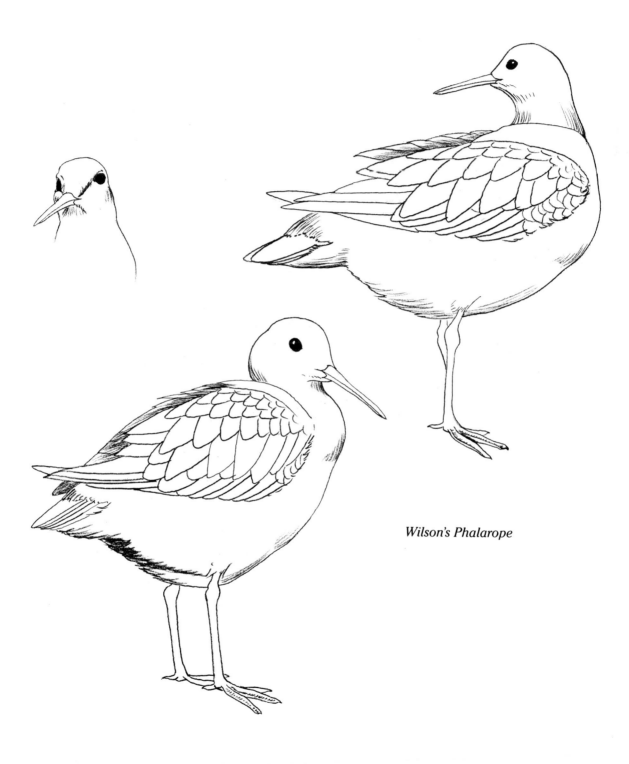

Wilson's Phalarope

9
Selected Reference Drawings

 The value of these line drawings rests on the fact that there is no other existing reference material that shows shorebird attitudes, proportions, and features, from conventional to unusual poses. The great variation in bills, legs, and bodies among the different shorebirds is apparent here, and these details are emphasized by the lack of color. The drawings should be studied carefully to form a thorough acquaintance with shorebirds.

How the legs bend and the placement of the legs in the body are shown not only from the side, but in many cases from the front and back as well. Notice how the legs angle toward a line down from the middle of the body to provide perfect balance. Toe length in relation to leg length is very important and is rendered as accurately as possible. Since shorebirds are seen feeding or walking more often than are other birds, many poses of this type are included.

The shapes of bills are viewed from various aspects to give a sense of the sculptural quality of the bill. Since shorebird heads are variously shaped, several views are drawn to show these unique forms. These different head views also serve to place the eye in relation to the bill when the head is seen straight-on as well as in profile.

Here, also, one can see how short the tail is and how it is usually covered by the primaries. The upper-tail coverts are almost never visible except when viewed from the rear or when the bird is tipped up, feeding.

Postures and attitudes that reflect behavioral changes may be seen in most of the drawings. Even the short-necked semipalmated plover exhibits the pulled-in neck when relaxed and the extended neck when excited. Look for the drooping scapulars covering most of the upper-wing feathers in a resting shorebird, and the pulled-back scapulars exposing much of the upper wing on a moving bird.

These are just a few of the things to look for in these apparently simple drawings. As mentioned previously, study them carefully. There is much to be seen.

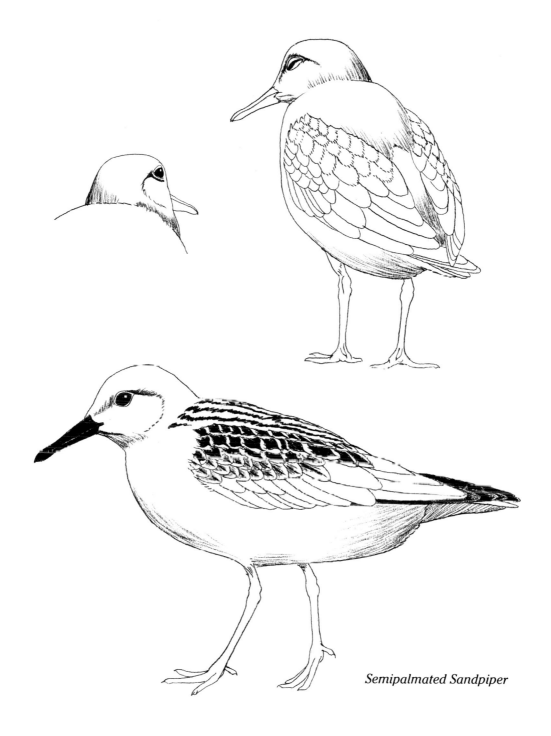

Semipalmated Sandpiper

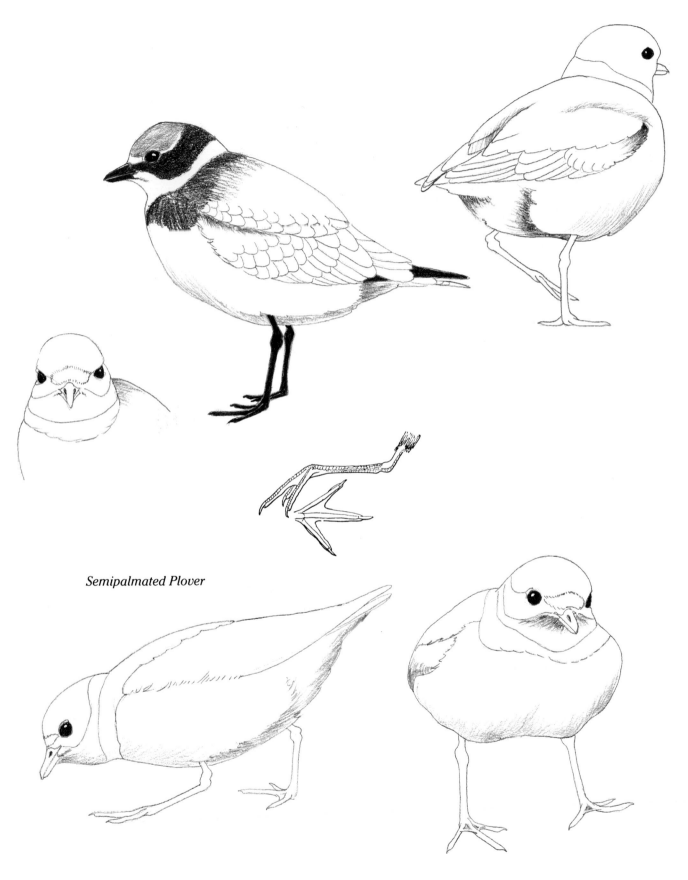

Semipalmated Plover

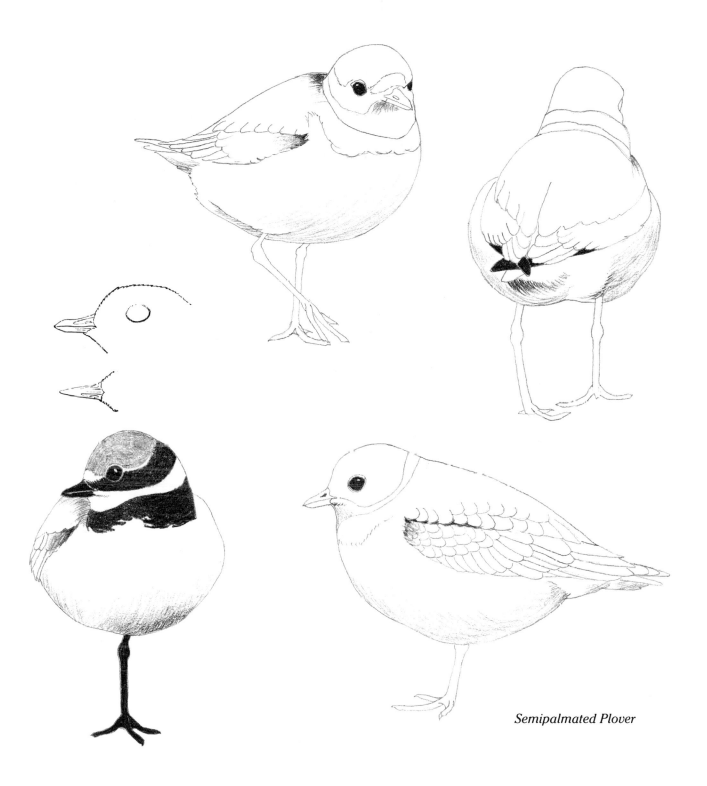

Semipalmated Plover

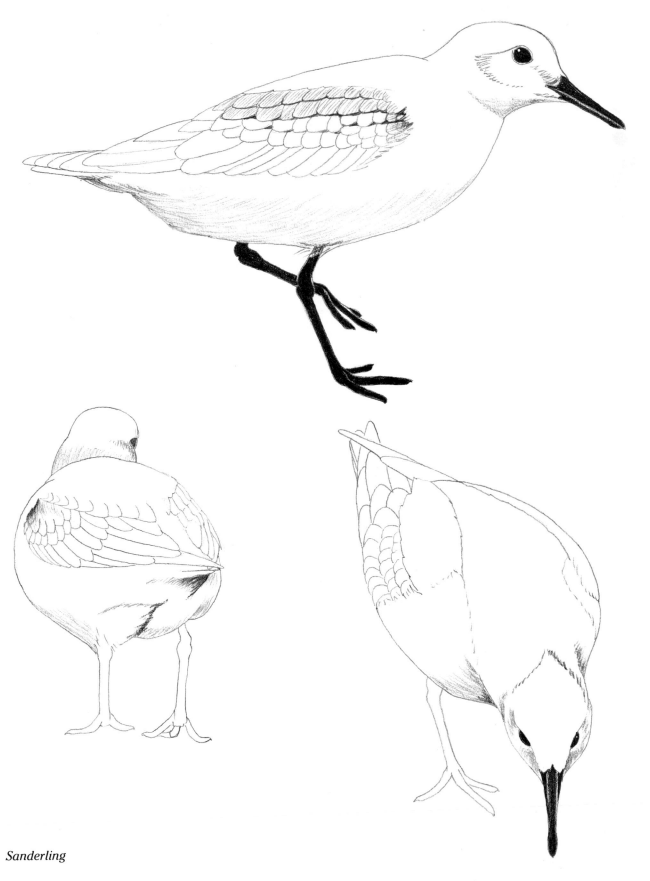

Sanderling

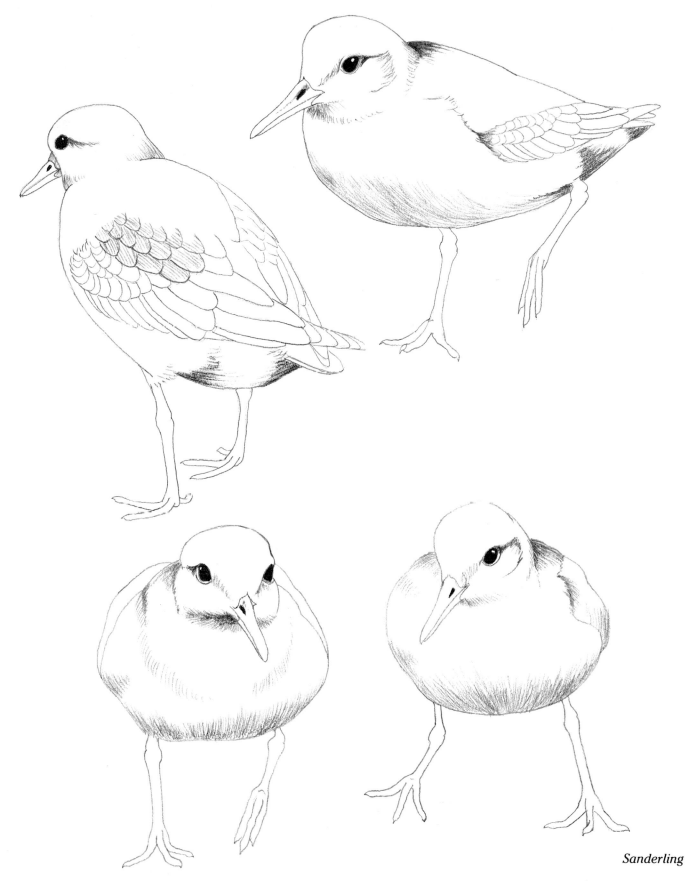

Sanderling

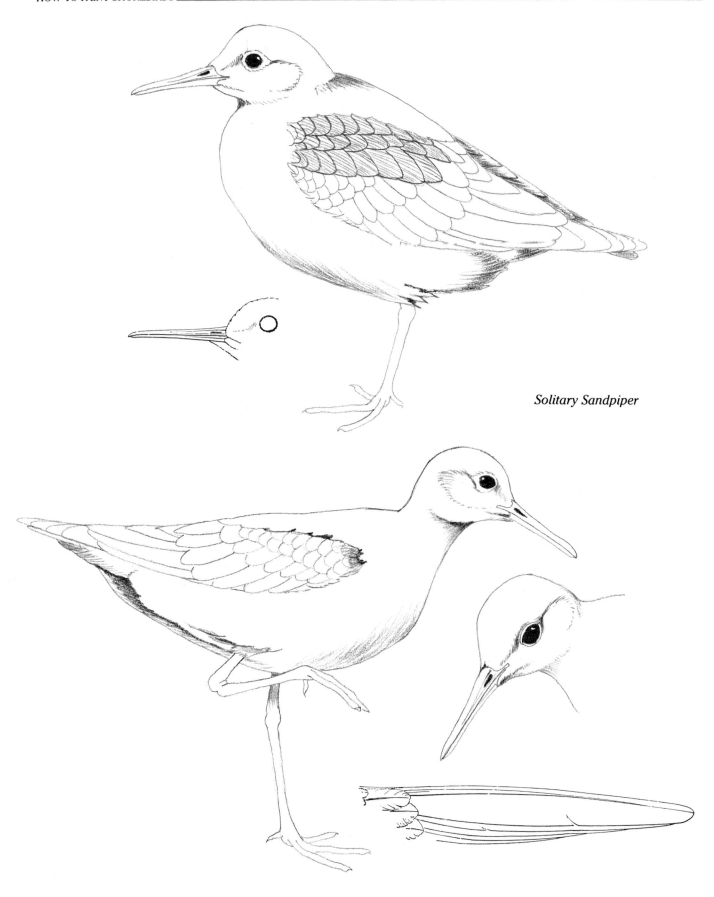

Solitary Sandpiper

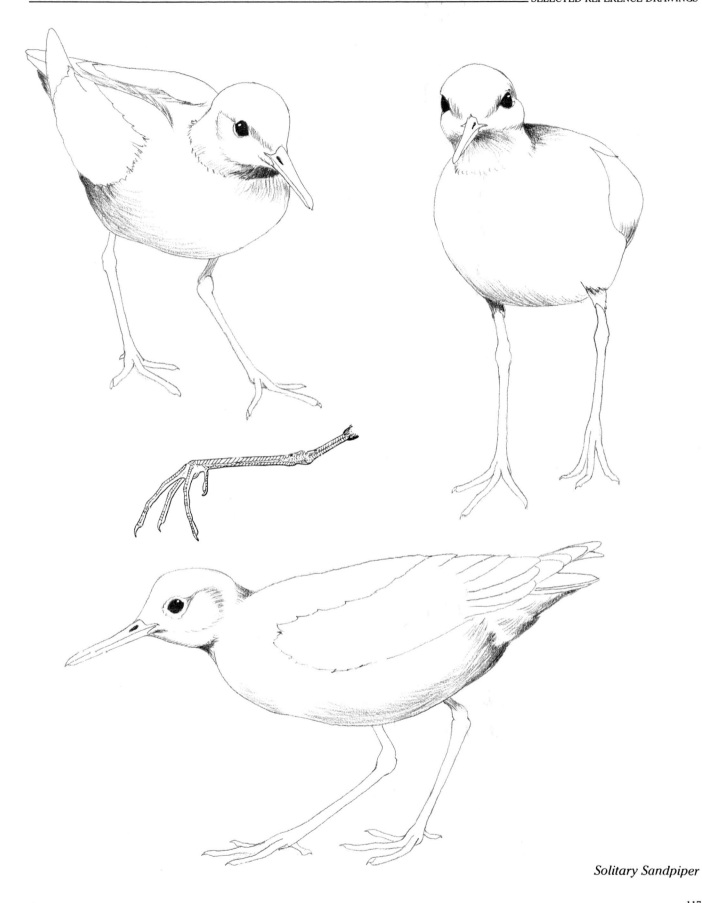

Solitary Sandpiper

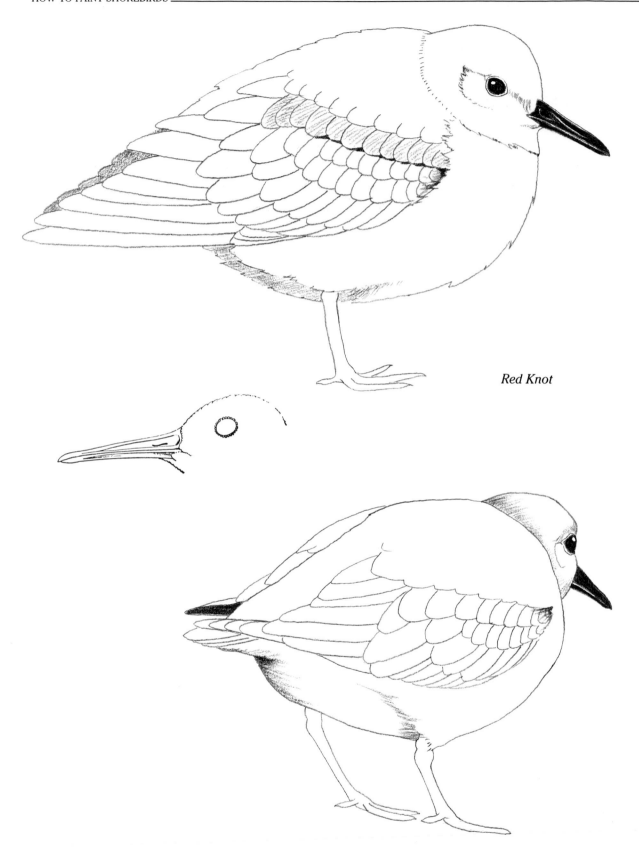

Red Knot

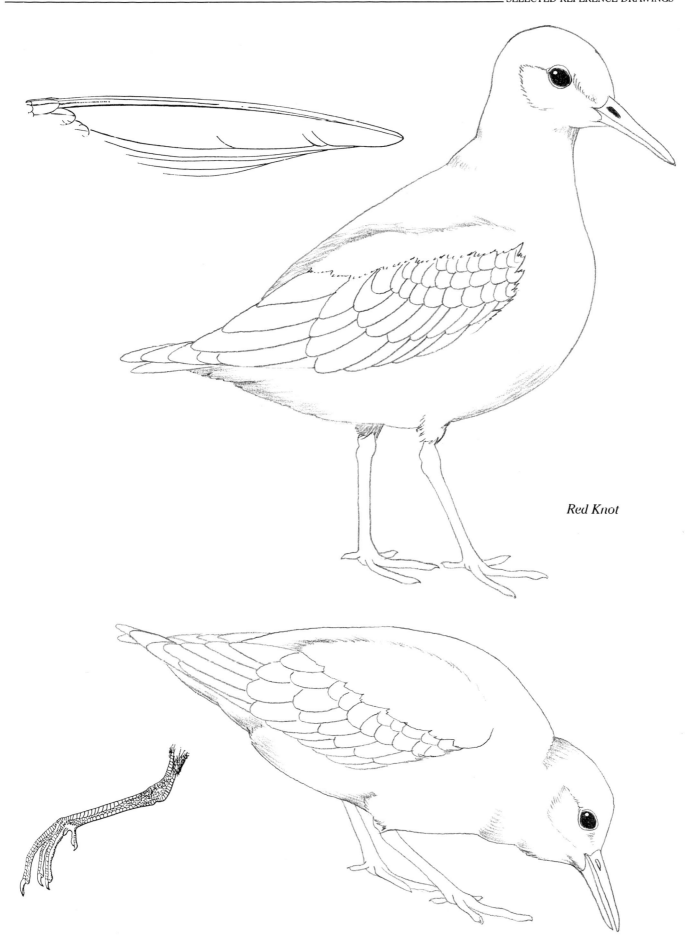

Red Knot

10
Reference
Material

 A frequent problem bird artists have is in obtaining adequate reference material. Although there is no substitute for observing the colors, attitudes, postures, and habits of birds in the wild, other reference sources must be considered because few of us have the ability to remember the field marks, color, and shape of a particular bird well enough to paint it accurately in the studio. However, when examining several reference sources, especially photographs and printed material, for a specific species of bird, you will notice wide variation in color for that bird from different sources. These color variations are due to many factors, ranging from the time of day a photograph was taken (flat midday light or warm afternoon light) to the accuracy of the printer in reproducing a color. The artist must choose his reference material carefully so that he can accurately portray the bird as he perceives it. The following are suggestions for sources of reference material.

Photographs. Most wildlife artists have a 35mm camera and telephoto lens to take their own reference photos of birds in the outdoors, whether in the wild or at the feeder. Original photos are an excellent source of material; however, they should be used as an aid, not as a crutch. Unfortunately, many bird artists rely exclusively on photographs they copy directly. Thus, their pictures are merely renderings of photographs—a far cry from original art.

Nature Centers, Sanctuaries, and Zoos. All these provide the opportunity to observe live birds, caged and free. Be aware that some physical features may be affected by captivity. Caged birds may have tattered wings and broken bills from flying against the cages. Also, some of the birds, especially at sanctuaries and nature centers, are brought in injured and could have broken wings or other disfiguring injuries that should be taken into account. Some loose yet captive birds are pinioned (wing tip removed) to prevent flight; this means there is only one complete wing. Though this reads like a list of horrors, such birds are well cared for and afford the artist an opportunity to closely observe some birds that are very difficult to see in the wild, even at a distance.

Books and Magazines. Both contain art and photographs that may be used for reference; most bird artists have files of material saved from magazines and other printed sources. There are scores of bird art books, some of which are useful sources of general reference. The rule here is: Don't use other artists' work as the *only* source of reference, for if an error was made in the original art, you will perpetuate it. Only use the art of others in conjunction with other reference material.

Preserved Specimens. Museums and nature centers usually have collections of preserved birds, as study skins, mounted in lifelike poses, or frozen, awaiting preparation. If you can gain access to these collections, they are excellent sources of reference material. The anatomical accuracy of mounted specimens may vary greatly, depending on how long the bird has been mounted and the skill of the preparator. Again, there are things to be aware of. As soon as a bird dies, even if it is frozen immediately, it loses, for lack of a better term, its "life force." It becomes smaller as everything collapses, and colors begin to fade immediately, especially in the legs and bill. Road and window kills also suffer the loss of "life force" and fading, and, additionally, there are state and federal laws governing the possession of shorebirds, dead or alive, without a special permit. Before keeping any

specimens, investigate local and federal laws with your state conservation department.

Carvers' Supply Sources. These stores sell feet, bills, and occasionally heads cast from actual shorebird specimens. A good reference source.

Reference Books

Audubon Society. *Field Guide to North American Birds Eastern Region*. New York: Alfred A. Knopf, 1977.

————. *Master Guide to Birding*, 3 Vol. New York: Alfred A. Knopf, 1983.

Austin, Oliver L. and Arthur Singer. *Birds of the World*. New York: Golden Press, 1961.

Burn, Barbara. *North American Birds*, The National Audubon Society Collection Series. New York: Bonanza Books, 1984.

Carlson, Kenneth L. and Laurence C. Binford. *Birds of Western North America*. New York: Macmillan Publishing, 1974.

Casey, Peter N. *Birds of Canada*. Ontario: Discovery Books, 1984.

Ede, Basil. *Basil Ede's Birds*. New York: Van Nostrand Reinhold, 1981.

Epping, Otto M. and Christine B. Epping. *Eye Size and Eye Color of North American Birds*. Winchester, Va.: Privately printed, 1984.

Gromme, Owen J. *Birds of Wisconsin*. Madison: The University of Wisconsin Press, 1974.

Hayman, Peter, John Marchant, and Tony Prater. *Shorebirds*. Boston: Houghton Mifflin Co., 1986.

Holt, T. F. and S. Smith, eds. *The Artist's Manual*. New York: Mayflower Books, 1980.

Hosking, Eric. *Eric Hosking's Birds*. London: Pelham Books, 1979.

Jeklin, Isidor and Donald E. Waite. *The Art of Photographing North American Birds*. British Columbia: Whitecap Books, 1984.

Johnsgard, Paul. *The Plovers, Sandpipers, and Snipes of the World*. Lincoln: University of Nebraska Press, 1981.

Lambert, Terence and Alan Mitchell. *Birds of Shore and Estuary*. New York: Scribners, 1979.

Lansdowne, J. F. *Birds of the West Coast*, 2 Vol. Boston: Houghton Mifflin, 1980.

Lansdowne, J. F., with J. A. Livingston. *Birds of the Northern Forest*. Boston: Houghton Mifflin, 1966.

Lansdowne, J. F. and J. A. Livingston. *Birds of the Eastern Forest*, 2 Vol. Boston: Houghton Mifflin, 1970.

Matthiessen, Peter. *The Shore Birds of North America*. New York: Viking, 1967.

Mohrhardt, David. *Bird Reference Drawings*. Berrien Springs, Mich.: Oak Bluff Press, 1985.

———. *Bird Studies*. Berrien Springs, Mich.: Oak Bluff Press, 1986.

———. *Selected Bird Drawings*. Berrien Springs, Mich.: Oak Bluff Press, 1987.

Perrins, Christopher M. and Alex L. A. Middleton. *The Encyclopedia of Birds*. New York: Facts on File Publications, 1985.

Robbins, Chandler S., et al. *A Guide to Field Identification—Birds of North America*. New York: Golden Press, 1966.

Saitzyk, Steven L. *Art Hardware*. New York: Watson-Guptill, 1987.

Scott, Shirley L., ed. *Field Guide to the Birds of North America*. Washington, D.C.: National Geographic Society, 1985.

Terres, John K. *The Audubon Society Encyclopedia of North American Birds*. New York: Alfred A. Knopf, 1980.

Tunnicliffe, C. F. *A Sketchbook of Birds*. New York: Holt, Rinehart and Winston, 1979.

———. *Sketches of Bird Life*. London: Victor Gollancz Ltd., 1981.

———. *Tunnicliffe's Birds*. Boston: Little, Brown and Company, 1984.

General Art Suppliers

There are many suppliers of general art supplies. Here are just a few, and most have a fee for their catalogs.

Pearl
308 Canal Street
New York, N.Y. 10013

Dick Blick
Box 1267
Galesburg, Ill. 61401

Arthur Brown & Bros. Inc.
P. O. Box 7820
Maspeth, N.Y. 11378

Daniel Smith Inc.
4130 1st Avenue S.
Seattle, Wash. 98134

Christian Hummul Co.
404 Brookletts Avenue
P. O. Box 1849
Easton, Md. 21601

Craft Cove
2315 W. Glen Avenue
Peoria, Ill. 61614

Wildlife Artist Supply Co.
P. O. Box 1330
Loganville, Ga. 30249

Product Manufacturers

Manufacturers will supply product information, color charts, and the names of local suppliers.

Koh-I-Noor Inc.
100 North Street
Bloomsbury, N.J. 08804
 Pelikan gouache

Winsor & Newton
555 Winsor Drive
P. O. Box 1519
Secaucus, N.J. 07096
 Acrylic paints and media
 Gouache paints and media
 Brushes

Robert Simmons Inc.
45 W. 18th Street
New York, N.Y. 10011
 Brushes

H. K. Holbein Inc.
Box 555
Williston, Vt. 05495
 Gouache

Fredrix/Tara
111 Fredrix Alley
Lawrenceville, Ga. 30246
 Artist canvas
 Watercolor paper

Crescent Cardboard Co.
P. O. Box XD
100 W. Willow Rd.
Wheeling, Ill. 60090
 Watercolor board
 Illustration board

Strathmore Co.
Westfield, Mass. 01085
 Watercolor paper
 Brushes

Grumbacher Inc.
Cranbury, N.J. 08512
 Brushes
 Paints
 Canvas

Delta
2550 Pellissier Place
Whittier, Calif. 90601
 Shiva Acrylics
 Brushes

Binney & Smith Inc.
1100 Church Lane
P. O. Box 431
Easton, Pa. 18044
 Liquitex Acrylic

Glossary

Acrylic Gesso. An acrylic polymer emulsion that can be either white or gray/black and serves as a ground for acrylic paints. This is not a true gesso as is used in oil painting.

Acrylic Paints. Pigments that are bound together with synthetic resins or polymer emulsions. Water based, they dry fast and hard and are not water-soluble when dry.

Binder. The substance used to coat and hold pigment in suspension and bind the pigment particles together when dry.

Blending. Bringing the edges of two colors together and mixing them to form a smooth transition rather than a hard line.

Blends. The combination of synthetic filaments and natural hairs used in the manufacture of brushes.

Boards. A paperboard of varying thickness that has a drawing, painting, or colored paper adhered to one side. Illustration, watercolor, and mat boards are all paperboards.

Bristle. The stiff rigid body hair of hogs and pigs, characterized by split ends on each bristle.

Canvas. Any woven fabric used as a painting surface. The two most common fabrics are cotton and linen, and they are classified by thread count and ounces per square yard. The finest canvas available is made from Belgian linen.

Complementary Colors. Colors opposite each other on the color wheel that, when mixed together, have a neutralizing or toning-down effect on the other; for instance, to tone down a bright yellow, add a very small amount of violet. The diagram shows a simple color wheel with the primary colors—red, yellow, blue—and their complementary colors. Orange is the complement of blue, green of red, and violet of yellow.

Consistency of Paint. Refers to the viscosity—thickness or thinness—of paint.

Designers Colors. See Gouache.

Detailing. Painting fine-line details on a picture or carving.

Dimension. In painting, refers to shading that gives shape, separation, or roundness to a form.

Drybrush. The technique of painting with very little paint in the brush to produce broken irregular lines or shapes.

Earth Tones or Colors. Naturally occurring in organic pigments that contain clay or silica, they are processed and produce very permanent colors, such as raw umber and raw sienna.

Ferrule. The metal, plastic, or quill sheath that holds hairs to the handle of a brush.

Filament. Any synthetic materials used in the manufacture of artificial brush hairs.

Filberts. Flat brushes that have rounded ends.

Finish. Describes the surface texture of a paper or board: hot press has a smooth finish, cold press has a medium finish, rough has an irregular finish.

Flats. Flat brushes with squared ends.

Flow Release. Synthetic or natural (ox gall) wetting agents that reduce the surface tension of paints, increasing their ability to flow more evenly.

Frisket. See Masking.

Fugitive Colors. Colors that are not stable and that fade or disappear over time.

Gels. Thickening agents added to paints that increase the impasto effect.

Glazing. Painting a thinned color over a dry base color so that the two mix visually and some of the base color shows through.

Gouache. (*Opaque Watercolor, Designers Colors*). A water-based opaque paint made with pigments, a gum binder, zinc white pigment, and other additives.

Grading. Creating a smooth transition from pure color to clear or no color.

Ground. A painting surface that serves as an absorbent stable base for the paint; for instance, acrylic gesso is a ground for acrylic paint.

Gum Arabic. A natural gum from the acacia tree, used as a binder for both gouache and transparent watercolor. It may also be added separately to give extra transparency.

Hair. Used in brushes, it is flexible and has a great degree of absorbency. The amount of spring, absorbency, and shape depends upon the animal the hair is from.

Hardboard. A composition-wood fiber board used in the construction industry. In its untempered form it provides a good painting surface when prepared with a ground.

Highlight. To emphasize an area on a painting surface that would catch and reflect intense light.

Impasto. Paint applied thickly to give a three-dimensional quality.

Lifting Off. A subtractive technique of moistening and removing dry paint.

Load. The amount of paint carried in the hairs of a brush. A full load is where the hairs are thoroughly saturated but not dripping.

Masking. Blocking out an area with liquid masking or paper to form a barrier that does not allow paint to penetrate its surface.

Matte Finish. A flat nonglossy finish.

Medium. The material in which an artist works or which, used as an additive, alters the materials.

Oil Paint. Pigments that use oils as binders and that require solvents and oils as thinning agents.

Opaque. The quality of a paint to cover a surface and not allow light to pass through it.

Opaque Watercolor. See Gouache.

Ox Gall. See Flow Release.

Ox Hair. Blunt hair from ox ears. Used in brushes, it is dyed red and called sableline.

Palette. Any surface used to hold concentrated paint for paintings.

Permanence. The degree of light-fastness of a color, the longevity of which depends upon many factors, including ingredients used in manufacturing, light, humidity, and pollutants.

Pigment. Coloring matter that is derived from natural or synthetic sources. Also used as a synonym for paint or color.

Premixed Colors. Shades of colors mixed by the manufacturer.

Retarder. An additive that slows the drying time of paints.

Round. The most commonly used watercolor-brush shape. The hairs are in a round ferrule and should come to a fine point.

Sable. Hairs in this category are from various members of the weasel family. They are generally characterized as having a fine point and great spring and strength. Kolinskys are the finest hairs in this group and come from the Asian mink found in Siberia.

Sableline. See Ox Hair.

Softening. Lightly brushing along the edge of a hard line to blend it slightly.

Soluble. Capable of being dissolved by a particular substance.

Spattering. Creating a random pattern of color spots or blobs, usually by snapping the bristles of a stiff brush held above the surface to be painted.

Splitbrush. Fanning the hairs of a brush until they split apart

Tipping. Touching only the tip of a brush to a surface and lifting or dragging it to produce various marks.

Tone. General coloring of an area.

Tooth. The texture of a surface, whether paper or gesso, which influences how the paint will appear. A smooth surface has less tooth than does a rough surface.

Transfer. The act of transferring or duplicating a drawing from one surface to another.

Transparent. In painting, the quality of paint that allows light to pass through it.

Transparent Watercolor. A water-based paint with a high concentration of finely ground pigments in a gum arabic binder.

Visual Weight. The perceived impact, brightness, and depth of a color.

Wash. The application of paint thinly or transparently: may be a continuous (even) tone, graded or glazed.

Watercolor Paper. Handmade or machine-made, a variety of fibers are used in their manufacture, including wood pulp, bark, cotton, and combinations of these. The finest papers are made from 100% cotton fibers.